RENAISSANCE PAINTING
FROM LEONARDO TO DÜRER

RENAISSANCE PAINTING
FROM LEONARDO TO DÜRER

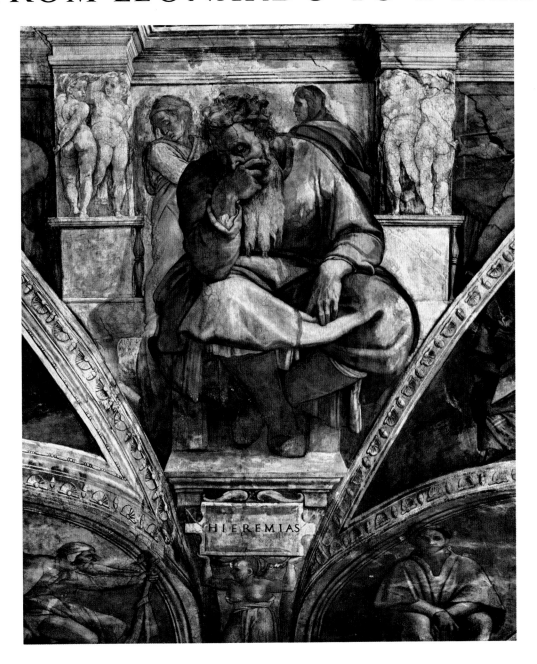

HIEREMIAS

TEXT BY LIONELLO VENTURI

RIZZOLI
NEW YORK

Originally published in the
GREAT CENTURIES OF PAINTING
series created by Albert Skira

*

Color plate on the cover :
Leonardo da Vinci (1452-1519). Portrait of Ginevra de' Benci, ca. 1474
National Gallery of Art, Washington, D.C.

*

Color plate on the title page :
Michelangelo (1475-1564). The Prophet Jeremiah, 1508-1511
Fresco, ceiling of the Sistine Chapel, Vatican

© 1979 by Editions d'Art Albert Skira S.A., Geneva
First edition © 1956 by Editions d'Art Albert Skira, Geneva

This edition published in the United States of America in 1979 by

Rizzoli INTERNATIONAL PUBLICATIONS, INC.
712 Fifth Avenue/New York 10019

Translated by Stuart Gilbert

Library of Congress Catalog Card Number: 56-9860
ISBN: 0-8478-0205-1

PRINTED IN SWITZERLAND

CONTENTS

I

THE RENAISSANCE IN ITALY

2

THE RENAISSANCE IN GERMANY

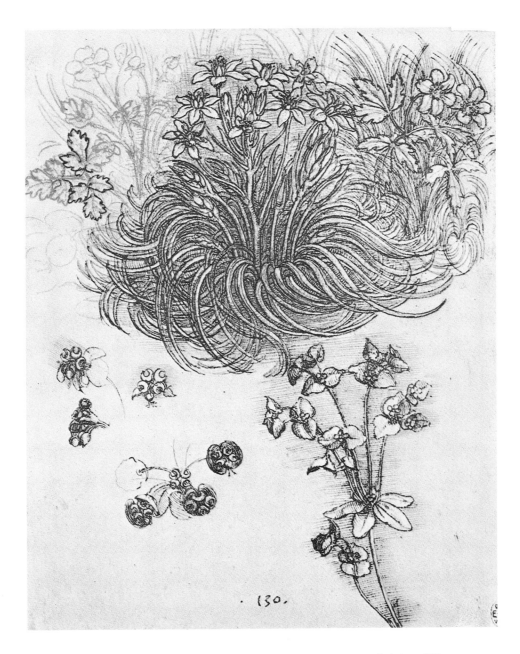

THE RENAISSANCE IN ITALY

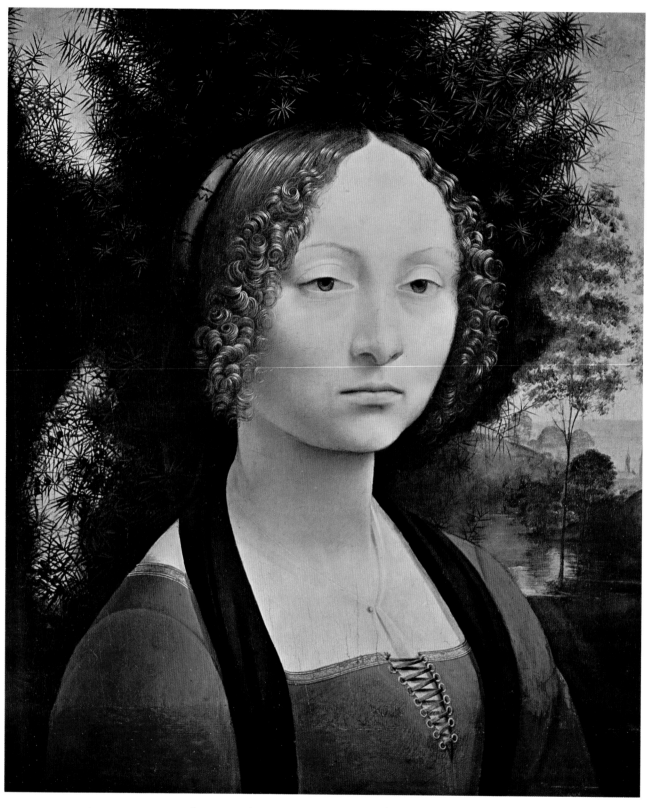

LEONARDO DA VINCI (1452-1519). PORTRAIT OF A LADY (GINEVRA DE' BENCI), CA. 1474.
(16½ × 14½″) NATIONAL GALLERY OF ART, WASHINGTON (FORMERLY LIECHTENSTEIN COLLECTION).

I

FROM LEONARDO TO CORREGGIO

WHEN a visitor to the Uffizi sees for the first time Leonardo's *Adoration of the Magi*, he is apt to be surprised by the dark, almost monochrome effect of the painting, in which rare glints of light strike through the shadows, no less than by the surging movement of the figures and the sense of mystery conveyed by purely plastic means. Alongside it the other contemporary Florentine paintings impress us with their bright precision and juvenile enthusiasm; whereas Leonardo seems strangely ageless, disillusioned, of no time and all time.

So dimly lighted are the Virgin and the Kings of the East that they look like phantoms. Around them all is plunged in shadows, a haunted dusk teeming with figures; some trying to break through the all-enveloping gloom; others responding to the divine summons. Among them we see an old man on the brink of death, his face twisted with emotion, a young man lost in meditation, St Joseph going about his humble tasks. A horse's head, much elongated, with quivering nostrils, is seen amid the crowd—a touch of fantasy to which the artist's creative imagination has somehow lent a curious plausibility. Behind these figures is a ruined palace with people on horseback and on foot moving to and fro, and beyond it a stretch of rocky country where mounted men are fighting a wild beast. A distant prospect summarily indicated in pale colors acts as a sort of backdrop to the action. The kings and their followers are crowding round the Madonna and Child. So much for the ostensible theme; the true significance of the picture lies elsewhere. What emerges from the shadows is an image of the tragic pathos of the human condition. Light, shade and movement conjure up forms hitherto unknown to art; line is implied rather than explicit, modeling is swept away on a tide of emotion, and space transformed into a fantastic vision in which all figurative elements are subordinated to psychological expression.

The *Adoration of the Magi* is unfinished. After making many studies of the lay-out and details in 1481, Leonardo ceased working on it when in the following year he was invited to Milan by the Duke Lodovico Sforza (il Moro). We may well believe that Leonardo was glad to leave this picture as it was; he had expressed, for himself and for posterity, all that he had to say and by the same token created a new style destined to shape all modern art. And to "complete" the picture at the bidding of others—in this case the monks of San Donato at Scopeto who had commissioned it—would have meant playing false to the creative urge behind it.

The *St Jerome* in the Vatican, another unfinished work, has all the remarkable qualities of the *Adoration of the Magi* and of certain drawings which reveal Leonardo's art at its best, since in them he could give free play to his imagination, untroubled by the exigencies of his public or his patrons.

He was twenty-nine when he painted the *Adoration of the Magi*, after working for several years in Andrea del Verrocchio's *bottega*, and though still a student had already gone far towards working out his personal style. To the *Baptism of Christ* (Uffizi), a work by his master, Leonardo contributed an angel very different from Verrocchio's angel in the same picture. The latter, shown full face, with the plastic values clearly rendered, is a young, healthy, rather material being with a childishly ingenuous gaze. Leonardo's angel is shown almost in back view, with the face turned in profile; in an attitude unknown to tradition and heightening the figure's expressive power. The cheek is slightly shadowed so as to round off the angles and add delicacy to the features, while soft lights play on the hair and some parts of the garment. This angel, too, is looking up, but there is nothing childish in his gaze, and the figure has a wistful charm, an almost feminine abandon. The freedom of the drawing and presentation and the spirituality of the face speak not only for Leonardo's rare creative genius but for a new moral outlook. Here beauty is replaced by grace.

The attribution of the *Portrait of a Lady* in the Liechtenstein Collection was long a moot point but today it is generally agreed that Leonardo was its maker, and this consensus of opinion testifies to the keener perception of the *quality* of a work of art that has, happily, developed among connoisseurs. For no man save Leonardo, in the decade from 1470 to 1480, was capable of creating a masterpiece of this order. The appeal of this portrait owes much to the cool, detached, disillusioned manner in which the young woman seems to be looking forth at the world; the face is noble, but without a trace of arrogance, the features are etherialized. One might almost see in this an *in memoriam* picture, the vision of a lovely lady in the land of Shades. Though her face is in some ways a reflection of the painter's mind, there is an antinomy between its physical features, whose sculpturesque volumes recall Verrocchio, and that very special attitude to life which was Leonardo's. Sometimes his creative vision outstripped the powers of his hand, great though these were. In any case the shadow on the cheeks attenuating their plastic structure, certain lights glancing across the woman's hair, the shape of the neck and the reddish-brown garments foreshadow unmistakably the style of his maturity. And it is fascinating thus to find the genius of Leonardo manifesting itself tentatively in a form he had not yet fully mastered.

Of this new form, which was to emerge in the *Adoration of the Magi*, there are early indications in several drawings, such as the pen-and-ink study of a *Madonna and Child* in the Louvre. The outlines of the bodies were treated sketch-wise and the numerous pentimenti, though they may look like "fumbling," were essential. The forms are not locked up within themselves but continuous, suggesting movement; they tighten or expand, merging into the shadows at the center, out of which the Child rises up, turning towards his Mother whose body, bent towards Him, is not delineated. Yet we

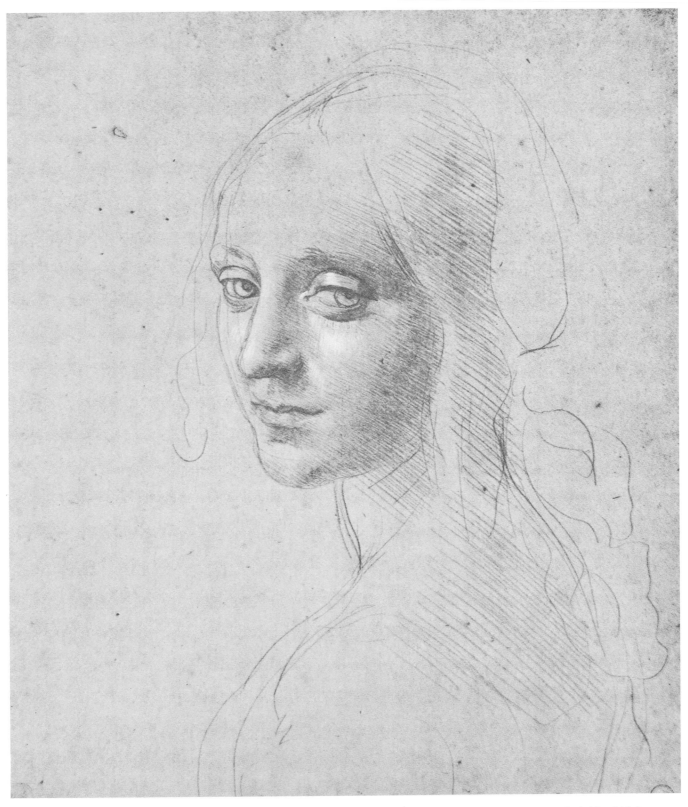

LEONARDO DA VINCI (1452-1519). STUDY FOR THE ANGEL IN THE "VIRGIN OF THE ROCKS." ($7\frac{1}{4} \times 6\frac{1}{4}$") SILVER-POINT DRAWING ON YELLOW PAPER. BIBLIOTECA REALE, TURIN. (ENLARGED IN REPRODUCTION)

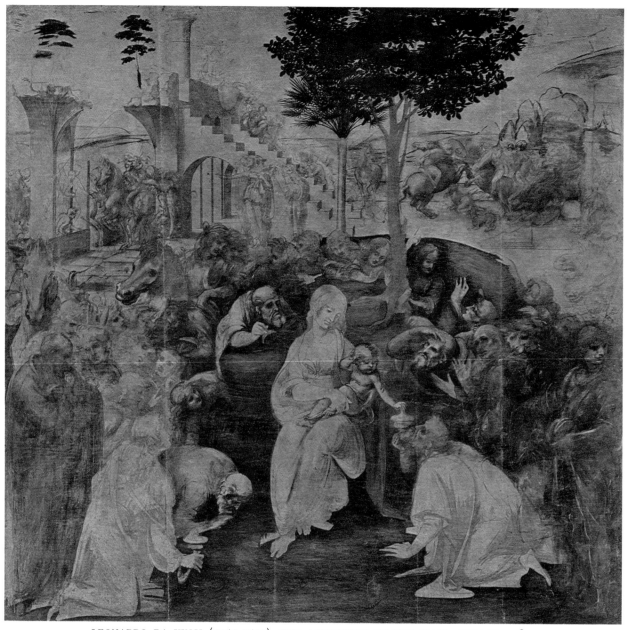

LEONARDO DA VINCI (1452-1519). THE ADORATION OF THE MAGI, BEFORE 1482.
(95 ½ × 96 ½") UFFIZI, FLORENCE.

palpably sense its presence, intimated by the face and hands—a body of exquisite delicacy, aerial lightness. The line defining the Child's limbs melts away into a sudden, unexpected patch of black; indeed the whole design is a skein of brilliant improvisations, a complex of infinitely varied accents. Nothing definite is seen, only ever-changing movement, flecks of light and shade dappling a uniform greyish-brown ground —the void. Before and after Leonardo, whenever Florentine artists aimed at suggesting color or producing an effect of strangeness, they clearly demarcated certain elements, leaving others in suspense. But Leonardo ruled out all well-defined forms without

exception; what he sought for was a vision self-sufficient, purged of all that was unessential, an art in which suggestion took the place of statement and material elements were submerged by light and movement. But besides its fine serenity and smoothly flowing movement, there is another quality distinctive of Leonardo's art: its grandeur, the effect of monumentality achieved by the suppression of extraneous details, avoidance of all over-emphasis and a telling synthesis of the lines of force.

The *Virgin of the Rocks* (Louvre) and the *Last Supper* (Santa Maria delle Grazie, Milan) are the only extant pictures made by Leonardo when he was attached to the court of Lodovico il Moro between 1482 and 1500. The composition of the former is governed by a single unifying principle, all the personages being interlinked by significant

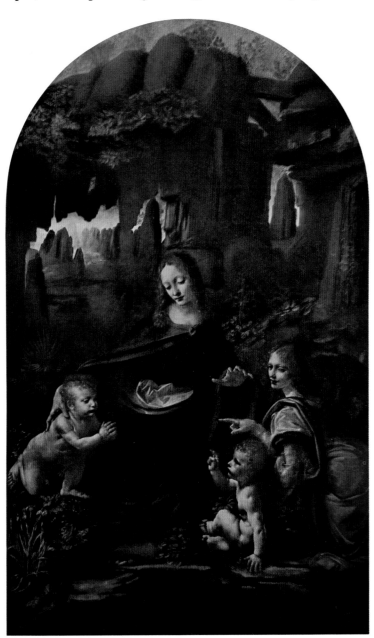

attitudes and gestures. The Virgin is gently urging the child St John towards the Christchild who is blessing him and behind whom the angel is pointing to St John. The lay-out is simple, forthright, well-nigh prosaic. Nevertheless the artist's handling of the scene is admirably free. Although the figures conform to a well-marked pyramidal schema, the dark central mass enables them to be spaced out. In short the picture reconciles two conflicting exigencies: the integration of the figures into an organic unity and their participation in the world of nature. As in the *Adoration of the Magi* the Virgin has the central place but instead of playing the leading part, she seems curiously aloof, absorbed in her musings, while the hands and faces of the others supply the "action." And the immateriality of her figure, lost in shadows, brings out the spiritual significance

LEONARDO DA VINCI (1452-1519).
THE VIRGIN OF THE ROCKS, 1483-1499.
(78 × 48″) LOUVRE, PARIS.

Photographed after partial removal of the varnish.

of the scene; after our eyes have vainly sought a resting-place on either side, they are drawn back irresistibly to the central figure, with its intimations of a mystery, its serene beauty and remoteness.

So as to fill the picture space in depth, the group is presented obliquely, but the linear pattern is also fully realized on the surface. The grotto acts as a background and the gentle light playing on the bodies ricochets on to the distant rocks. But everywhere shadow predominates, bathing the images in an atmosphere both meaningful and evocative. Discarding outright contrasts of light and shade, Leonardo has modulated the light throughout a long recession towards the shadows, in which all is modeled in a soft penumbra. The problem he set himself in this picture was one of reconciling contraries; of realizing a composition at once unified and dispersed, delineated on the surface yet suggesting depth; and of handling forms in such a way that, while having relief, they were absorbed into the atmosphere—a composition in which each detail was clearly stated yet subordinated to the general effect. A solution was provided by his famous *sfumato*, rippling like a fluid over surfaces and molding forms. And besides being a stylistic expedient, *sfumato* also served to realize the poetic ideal voiced by Leonardo in some well-known passages of his Treatise on Painting.

"Observe how in the evening, when the weather is rainy, the faces of the men and women you meet on the roads acquire a singular grace and gentleness..."

"A wonderfully soft play of light and shade can be seen on the faces of people sitting on the doorsteps of houses in the shade. Looking at them, you find that the shadowed portions of these faces are blurred by the shadows of the houses... and much beauty can be brought to features by a skillful heightening of this play of light and shade."

If for the doorsteps of houses at nightfall we substitute the mysterious grotto, we can see that Leonardo achieved his dream of beauty in the *Virgin of the Rocks*. His predilection for the soft, diffused light of the hour when the day is dying and night has not yet come prevented him from troubling overmuch about color. While in *sfumato* —the blending and softening of light tones into dark—form acquires a wonderful delicacy, colors tend to be submerged and here they are no more than tints having no local values and melting into the dusk of nightfall. Leonardo's light is functional to form, but not to color. When he applied himself to perfecting a picture such as this, the vision that held his gaze was one of perfect grace; what he aimed at was to conjure up out of an all-enveloping *sfumato* unforgettable faces, like those of the Virgin, St John and the angel. Buoyant forms, uninfluenced by the pull of gravity and so exquisitely fragile that they seem less like real beings than like the figures of a dream, they do not belong to Raphael's world of beauty, but to a world of heavenly grace.

In 1504 the Duchess Isabella d'Este Gonzaga wrote to Leonardo asking him to paint a picture of the Child Jesus endowed with "that suavity and sweetness in the expression which you alone can compass." This shows that it was to his "suavity and sweetness" that Leonardo owed his success in court circles, a success we can readily understand in the light of the *Virgin of the Rocks*. But eulogies of this kind must have struck the creator of the *Adoration of the Magi* and the *St Jerome* as involuntarily ironical.

True, with the *Virgin of the Rocks* he had proved to himself that, given time and with infinite pains, he could really "finish" an oil painting. But on this matter of "finish" he was always in two minds. He completed a picture in order to "triumph," as he put it; on the other hand, so far as his personal satisfaction was concerned, the sketch sufficed, since in a drawing he could express himself with perfect freedom. One reason for this attitude he shared with the greatest painters of the day; neither Michelangelo nor Giorgione greatly cared to "finish" their works. For this was a time when the distinction between the artist and the artisan was coming to the fore and the artist was impatient with what he looked on as manual labor, the craftsman's proper function. Moreover, Leonardo saw himself, and rightly so, as a pioneer in many fields; his was indeed a universal genius. This was recognized by his contemporaries who ascribed magical properties to his "inventions," but, aside from his discoveries in anatomy, hydraulics and many other branches of science, what grip the modern imagination are his anticipations of the future, his plans for submarines and airships. It has been said, correctly, that if these plans were never carried out, the fault lay entirely with the age he lived in. Actually, however, to Leonardo's thinking, the theoretical value of an invention lost nothing by remaining dormant in his notebooks; and he took much the same view as regards his activities in the field of art.

A long-standing practice of the art historian is that of attaching particular importance to works on which an artist has expended much time, which he has painstakingly brought to what is called perfection. Raphael is an obvious case in point; as between his small picture of *St George* and his big fresco, the *School of Athens*, the latter has always attracted more attention. But a discussion of the reasons behind this preference would take us too far afield. We will merely suggest that there are no substantial grounds for deploring the fact that, owing either to his temperament or to the circumstances of the age, Leonardo finished so few works. Indeed his failure to complete the *Adoration of the Magi* may well have been a blessing in disguise. Though the angel in the *Virgin of the Rocks* has more graciousness, more sweetness, as compared with the preliminary sketch (Turin), we find in the latter a more intense and mysterious vitality, superior creative power.

But have we here the true Leonardo, the man of heaven-scaling ambition, first great painter of light and a pathfinder of modern science both theoretical and applied? Put this way, our question suggests that ravishing as is the beauty of his angels, this represents but one facet of Leonardo's many-sided personality. His culture and, more particularly, the neo-Platonist influences then predominant in Florence led him to follow up this path, his immediate aim being to "triumph" (as he styled it) and to gratify Isabella d'Este or the King of France. Obviously this new grace was a notable discovery; which is why it had so many imitators. But Leonardo's ultimate goal lay elsewhere; he was in quest of something more deeply rooted in life, something exclusively his own —something which was never to be imitated.

Writing from Florence in 1501, Pietro da Novellara informed Isabella d'Este that Leonardo was working on his *St Anne,* and added: "He has done nothing else, except

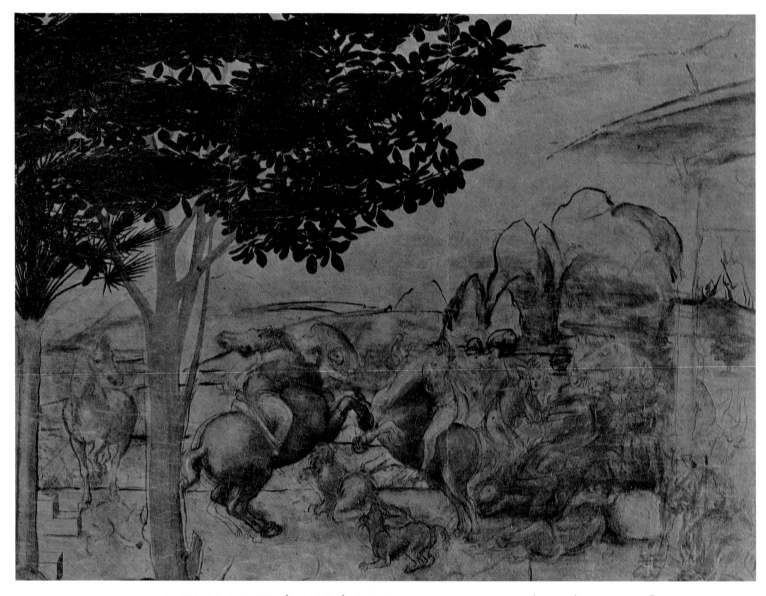

sometimes touching up the portraits that two of his assistants are engaged on." Thus it is impossible to say if the many portraits that at one time or other have been ascribed to him are really by his hand—with the exception of the *Monna Lisa*. Moreover, the uniqueness of this picture, into which Leonardo poured his whole soul, makes it difficult for us to see him in other portraits. In any case his imagination was obviously too personal, too autonomous, for portrait-painting—as indeed is evidenced by the *Monna Lisa*. The intellectualism, the visionary remoteness we see in La Gioconda's gaze was Leonardo's, not his model's. His, too, that intimation of a mystery, an immemorial wisdom that "all the thoughts and experience of the world had etched and molded" in her face, hinted at not only by the enigmatic smile but also in the dim, fantastic

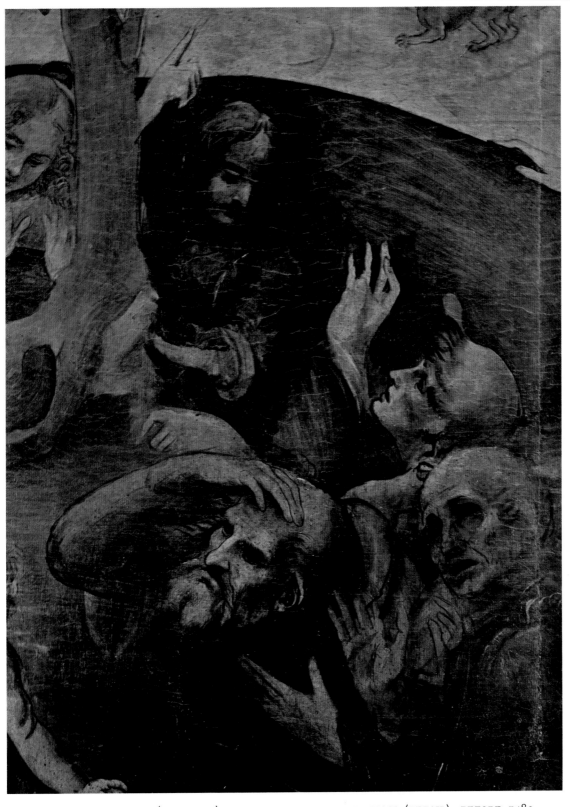

LEONARDO DA VINCI (1452-1519). THE ADORATION OF THE MAGI (DETAIL), BEFORE 1482.
UFFIZI, FLORENCE.

LEONARDO DA VINCI (1452-1519). THE ADORATION OF THE MAGI (DETAIL), BEFORE 1482.
UFFIZI, FLORENCE.

landscape; this is a Faustian face rather than a woman's. So multifarious are the allusions, so diverse the meanings behind meanings, that sometimes the beholder has almost an impression of a plethora of subtleties. Nevertheless despite its structural complexity, the artist has imparted to the picture itself a wonderful simplicity; here he brought off another "victory," but this seeming ease cost him infinite labor—extending, Vasari tells us, over many years.

The fact that we can trace the successive stages in the making of the *St Anne* enables us to follow the evolution of Leonardo's style during the last years of the century and up to 1506 or thereabouts. The earliest sketches show that he originally intended to depict the Holy Family in a very human, intimate way; but subsequently decided for a more monumental, fully plastic treatment. The final outcome was the picture in the Louvre, in which the movements and gestures of the figures are determined by the exigencies of a monumental lay-out. The composition is based on that dialectic relationship of masses known as *contrapposto*, being so disposed that a gesture on the right is promptly balanced by another on the left, the result being a dynamic symmetry wherein intellectual values are transmuted into art. Thus at the turn of the century Leonardo realized that monumentalism was to be the keynote of Cinquecento art and showed artists how it could be attained.

But beauty even when interpreted on monumental lines was for Leonardo only a milestone on the path he had mapped out for himself; he aspired to nothing short of imparting a new, revolutionary significance to the human situation, and the dramatic played a necessary part in it. While there had already been hints of this in the *Adoration of the Magi*, it comes out unmistakably in the *Last Supper* painted for Santa Maria delle Grazie in Milan and completed or almost completed in 1497. This picture is in a sadly damaged state and we have to refer to the drawing to get an idea of the expressions on the faces. Nevertheless the monumental grandeur of the ensemble can still be seen in the fresco. This effect is due both to the architectural framework rigidly enclosing gestures and to the rhythmical balancing of the groups of disciples on either side of Christ. Christ has just told them "One of you shall betray Me" and the disciples react to the tragic tidings each in his own manner and at successive intervals of time. Among those nearest Christ, John and Philip are overwhelmed by their emotion. Peter in a gust of apprehension thrusts Judas aside, Thomas and James the Greater make no secret of their horrified surprise and indignation, while on the two groups furthest from the Savior the effect of the announcement is less pronounced—as though attenuated or retarded by their distance from the central figure. Thus the expressive variety of gestures creates at once a sense of the lapse of time and a complex symmetry, adding spiritual overtones to the rendering of the scene.

Intended to decorate (in competition with Michelangelo) one of the walls of the Council Hall in the Palazzo Pubblico, Florence, the *Battle of Anghiari* would have displayed Leonardo's feeling for the dramatic at its apogee. But the mural was never completed, and all we have to go on are some sketches and a written description. Judging by the accounts of those who saw the cartoon, the central scene was a seething mêlée of

men and horses whose frenzy seemed to electrify the surrounding atmosphere, laced with smoke and flames. In the sketches, the scope of the action is limited by considerations of a formal order. Yet no one before or after him has rendered the immediacy, speed and drive of headlong movement with such compelling power as in these drawings. In the picture he achieved not only perfect form but a remarkable compositional equilibrium. The battle is depicted in three episodes, as in a triptych. It begins with a combat between two men on horseback; in the central scene we see the terrific struggle for the colors which gave this work its alternative title the "Battle of the Standard"; and finally the cavalry held in reserve. Thus the composition included a sequence of events in time and space—though the latter was perforce constricted.

Basic to Leonardo's style was his *sfumato*, that fusion between form and color-light which made it possible to bathe the image in a "vapory" atmosphere and to body forth the conception of a world in which man was not, as in the 15th century, a protagonist, but an element of the universe on a par with earth and sky. Hence the importance Leonardo assigned to landscape, which, however fantastic or remote, sets what might be called the picture's moral tone. Far from wishing to limit painting to the portrayal of man and his activities, he sought to include all nature in his art—rain, sky and stars. For Leonardo perspective was no longer merely geometric, it could also be chromatic and convey the density of the atmosphere intervening between the beholder and the distant image, thus causing nature to play a part in the human situation.

Leonardo's conception of painting linked up with his scientific theories. It is hardly necessary to point out that he tackled many of the problems dealt with by modern science, and that he actually made blueprints of several inventions that have materialized in our time. In Florence throughout the 15th century science and religion had marched side by side and gradually the function of directing operations of the mind had been withdrawn from the latter and assigned to science. Leonardo, however, broke with the neo-Platonic tradition of the Quattrocento and, embracing Aristotelian realism, studied the world of nature without any idealistic bias. He believed like Aristotle that nature was guided by an inner Reason of her own that manifested itself in her operations and that what the scientific researcher had to do was, starting from the data of experience, to work back to the rational principles—of a mathematical order—that govern the phenomenal world. Pencil in hand, Leonardo embarked on this adventurous quest. The first truth he encountered on his path was that of beauty, the living poetry of graceful forms. Next he discovered the unity between force and movement and in this he saw a key to the tragic predicament, religious and political, of his time. Beyond these came pure science, and since this lay wholly outside the scope of the culture of his day, Leonardo transposed his ideas into the future, when thanks to science man would master his environment, just as Machiavelli projected into the future the political system he had set his heart on but could not get adopted. And both men sensed the poetry of the unfinished.

His contemporaries were alive to the grandeur of Leonardo's art and freely drew inspiration from his *sfumato*, his monumental vision and his feeling for movement.

LEONARDO DA VINCI (1452-1519). THE ADORATION OF THE MAGI (DETAIL), BEFORE 1482.
UFFIZI, FLORENCE.

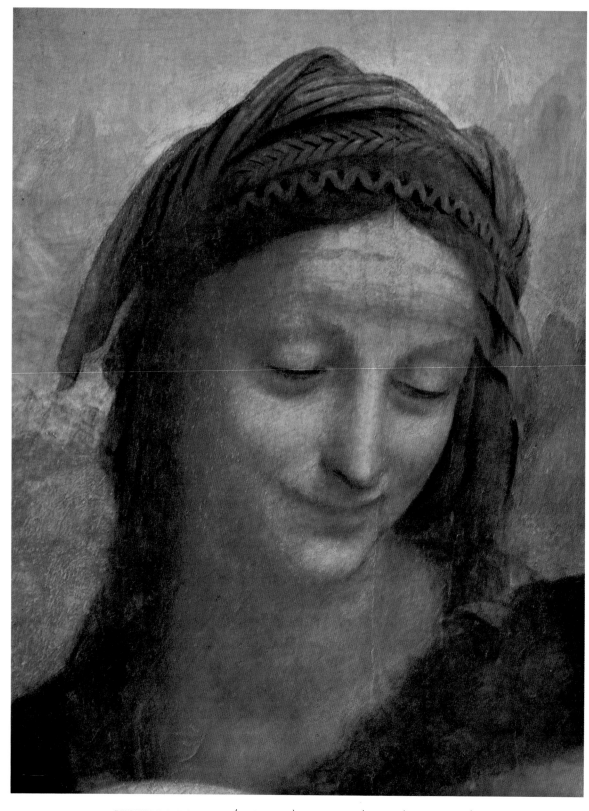

LEONARDO DA VINCI (1452-1519). ST ANNE (DETAIL), 1501-1506.
LOUVRE, PARIS.

24

LEONARDO DA VINCI (1452-1519). ST ANNE (DETAIL), 1501-1506.
LOUVRE, PARIS.

They also exploited his knowledge of hydraulics and military engineering. But they felt that there was something faintly sinister about this man who so resolutely went his own way, whose knowledge was encyclopedic and whose capacity for invention seemed superhuman. The milieu he frequented was highly lettered, but Leonardo boasted of being "an unlettered man," and of preferring to be a painter, philosopher and scientist. After winning Isabella d'Este's enthusiastic patronage by the charm of his painting, instead of humoring his patroness, he promptly diverted his energies to inventing a new machine. In Rome Pope Leo X did not know what to do with him and finally Leonardo migrated to the court of Francis I in France, where he died in 1519. Perhaps the most striking thing about this man of many-sided genius was his amazing faculty of living in the future more than in the present.

THE CRISIS OF THE RENAISSANCE

It is common knowledge that the last decade of the 15th and the first three of the 16th century witnessed a wonderful flowering of painting and sculpture in Italy, an art whose classical perfection is comparable with that of the Golden Age of Greece. To this period belong the masterpieces of Leonardo, Raphael, Giorgione and Correggio; most of Michelangelo's and Titian's; and a host of epoch-making works. In other fields, Ariosto's *Orlando Furioso*, the political and historical speculations of Machiavelli and Francesco Guicciardini, and the discoveries of the great sea-captains contributed to the prodigious intellectual ferment prevailing in Italy during those crowded, colorful years. There was thus a striking contrast between the political, religious and economic calamities of the peninsula and its signal triumphs in the domains of art and the intellect.

The period between the French invasion under King Charles VIII in 1494 and the year 1530 which witnessed the downfall of the last Florentine republic was politically disastrous for Italy. Not only did the country come under foreign domination, destined to last three centuries, but it was ruined economically as well, and the triumphal progress of the Renaissance was brought virtually to a standstill. Nor did the Catholic Church of Rome fare much better; its authority was seriously undermined by the Reformation; in fact it seemed as if Savonarola's maledictions were being fulfilled and the Church being castigated for her all too obvious delinquencies.

To account for the anomaly between artistic achievement and political collapse we must bear in mind the relations then obtaining between the Church and the community, and the change of outlook that had taken place. In the Middle Ages the artist created for the glory of God; a cathedral or a fresco might be a work of art but its point of departure was an ideal concept stemming from a loftier source. It was only during the Renaissance that the work of art came to be viewed from the aesthetic angle, as something existing in its own right. There was no longer any question of transcendance; the artist could be a-moral without being immoral, and Machiavelli's ideal ruler was confessedly unscrupulous.

The myth of a "renewal" bulked large in the *Weltanschauung* of the Renaissance, and it was this yearning for a revival of the perfection they read into the arts of antiquity that led the 14th- and 15th-century Italians to hark back to the culture,

prized so highly, of the Greeks and Romans, without however relinquishing their own Christian ideal. But the impulse to renewal was already flagging when the 16th century began; it might indeed be said that the Renaissance unwittingly transmitted this "revivalist" trend of thought to its arch enemy, the Reformation. Acting as its spokesman, Savonarola had launched a program of reform in Italy and though he failed, his ideal and his aspirations had survived his death (1498). During the 1529-1530 siege the heroic resistance of the Florentines was sustained by the proclamation of "Christ, King of Florence," in memory of Savonarola. But Malatesta Baglioni, after reviewing the military situation, was convinced that, notwithstanding the Florentines' faith in Christ the King, defeat was inevitable and, judging it expedient to surrender, secretly negotiated a treacherous agreement with the besiegers. Thus in this city which for over a century had led the way in European culture, their mystical faith enabled its inhabitants to perform feats of legendary valor; whereas rationalist logic, in the absence of a secular morality, led to an act of abject treachery. It was not until the Age of Enlightenment that a moral code based on purely secular principles came into being.

It is interesting to observe how the great Italian painters reacted to the political and social conditions of their day. Leonardo perfectly understood the nature of the change that was taking place. He was the first artist to humanize a scene like that in the *Adoration of the Magi*, and to dramatize the *Last Supper* to an extent unparalleled in any work of the previous century. Nevertheless Leonardo viewed the contemporary predicament with detachment; one has a feeling that his moral sense was not strong enough to prompt him to commit himself. It was, above all, scientific research that fired his enthusiasm; and by engrossing himself in that, he lived more in the future than in the present. Therein lay both his strength and his limitations. He built up an art of pure intelligence with scant regard to the material means employed—one of the results being that many of his paintings rapidly deteriorated. Art was for him the supreme truth, but he ranged beyond art, exploring many branches of science. Unfortunately the technical equipment he needed was lacking in his time.

In the early 16th century Florence still held the lead in the intellectual life of Italy, though now and again some of her greatest citizens were driven into exile. In 1505 the city called on Leonardo and Michelangelo to decorate the Hall of the Great Council in the Palazzo Pubblico, thereby demonstrating that Florence still could achieve what lay beyond the power of other cities. But neither artist did more than draw up some preliminary plans. The great days, in fact, were over and Rome now stepped into the place of Florence. In 1505 Pope Julius II summoned Michelangelo to Rome, and Raphael followed him three years later. They were employed on painting the Sistine ceiling and the Stanze of the Vatican, respectively. From 1508 to 1520 most of the art of Italy (with the exception of Venice) was produced at Rome under the auspices of Julius II and Leo X.

Raphael is one of the most popular artists of all ages and not without good reason. Still we cannot forget that he worked in something of a hot-house atmosphere and solely for an art-loving élite.

Julius II liked to do things in a big way, and, wishing to build for himself a colossal tomb, he called in Michelangelo who was no less enamored than he, perhaps even more enamored, of the impossible. When the project for the tomb fell through, the Pope commissioned Michelangelo to decorate the ceiling of the Sistine Chapel. For building the new St Peter's, the largest church in Christendom, he called in that architect of genius Bramante, who, an old legend has it, had announced the singular intention of making the road to Paradise passable for vehicles, once he was on the Other Side! The commission for the Stanze went to Raphael whose gift of imparting grace and charm even to the most grandiose conceptions commended him to Julius II. This great pope's predilection for huge monumental works of art was certainly motivated by the religious and political conditions of the age. Since there could now be no question of regaining the Franciscan virtues of humility, chastity and charity, the only alternative was to bolster up the prestige of the Church by a display of strength, beauty and grandeur. In short, the ideal of Julius II and his associates was to steal their thunder from the ancient Romans, and compete with them on their own ground.

Son of Lorenzo the Magnificent, Leo X was educated by Politian and liked to boast that he was "born in a library." He devoted even more time than Julius had to literature and art, his interest in culture and intellectual pursuits even leading him to neglect affairs of State. At his court the obsession with antiquity reached a point where Christ was assimilated to Apollo and the Virgin to Diana. Erasmus was scandalized by a Good Friday sermon preached by Cardinal Inghirami, who in the presence of the Pope discoursed eloquently on pagan subjects and completely forgot to make any reference to Christ's Passion.

Living in a constant round of festivals and banquets, Leo X failed to recognize the seriousness of Luther's revolt and its menace for the Holy See. On the other hand, he seems to have realized that Raphael's untimely death in 1520 spelt the end of his dream of a new golden age of art, and when the Romans one and all went into mourning he, like them, obscurely felt that the loss of their "divine painter" was a portent of decline. Leo X died next year and was succeeded by a Dutch pope who cared nothing for art. And only a few years later, in 1527, came the sack of Rome, prelude to the end of the Renaissance. Yet when we remember what was then happening throughout Europe and the calamities still to come, we can see that Rome was for some while yet a favored oasis, a refuge from the storm—and still capable of producing masterpieces.

THE SCHOOL OF LEONARDO IN LOMBARDY AND TUSCANY

All Italian painting was influenced by the new ways of seeing and the aesthetic Leonardo had brought into the world. Generally speaking, the painters who worked in his immediate orbit are not greatly appreciated today (the same fate has befallen Raphael's, Michelangelo's and Correggio's satellites). It has been said that the Lombards oriented Leonardo's innovations towards a sentimental art, and the Florentines towards an academic classicism. There is some truth in this, yet it is only fair to recognize that a number of works exist which, if not wholly by the Master's hand (though he may well have had a share in them), rank among the finest creations of the Italian Renaissance.

For example we find Novellara writing in 1501 to Isabella d'Este about the two pupils who were making portraits in which the Master "sometimes helped them." True, as a result of modern research many works traditionally ascribed to Leonardo are now excluded from the canon; but this does not detract in any way from their charm. Noteworthy examples are the *Portrait of a Musician* and *Woman in Profile* (Ambrosiana, Milan) and the *Portrait of a Nobleman with Long Hair* (Brera, Milan). The version of the *Virgin of the Rocks* in the National Gallery, London, was a joint work of Leonardo and De Predis. Here the monumental quality is more pronounced than in the Louvre version, but the latter has a more intense vitality. By and large it may be said that the Lombard painters successfully mastered the use of Leonardo's *sfumato*—they had already been initiated into it, to some extent, by Flemish painting— while keeping to the Quattrocento tradition of humanistic realism imbued with charm. What they failed to understand in Leonardo was the intellectual side of his art; that he saw in art a means to the enlargement of knowledge.

Ambrogio De Predis was Leonardo's chief collaborator at Milan. De Predis was a miniaturist who in 1502—twenty years, that is, after Leonardo's coming to Milan— made his *Portrait of the Emperor Maximilian I* (Vienna); but in this picture, excellent in its way, the precise rendering of details is a far cry from Leonardo's art.

A painter of very different caliber was Antonio Boltraffio (1466/67-1516). His only master was Leonardo in whose studio he worked and whose technique he skillfully assimilated, but without effacing his own personality. The composition of his *Virgin and Child* (Poldi-Pezzoli Museum, Milan) is based on an harmonious relationship of contrasted masses, and the obscurity of the *sfumato* is happily allied with rich, resonant colors; but most striking is the grace, at once discreet and noble, that sets this picture in a class apart. This delicate expressiveness, tinged with idealism, is also found in the *Portrait of a Man* (possibly Girolamo Casio of Bologna) in the National Gallery, London, while in the *Madonna of the Casio Family* (Louvre) the artist displays a keen feeling for architecturally ordered composition that, while deriving from the Quattrocento, has the new freedom of movement characteristic of the 16th century.

Bramante's pupil Bartolomeo Suardi, known as Bramantino (ca. 1480-ca. 1536), shows an admirable feeling for tectonic structure not only in his composition but also in his figures—an effect which is, however, weakened when he takes to displaying his mastery of *sfumato*. Of much interest, too, are the painters who, thanks to their familiarity with Venetian painting, breathed new life into traditional 15th-century Lombard art; such men as Andrea Solario, Bartolomeo Veneto and Bernardino Luini.

Andrea Solario (op. 1493-1524) imparted to his Madonnas a look of motherly love that is infinitely touching. His famous *Vierge au coussin vert* (Louvre) has a charm all its own, spontaneous and sincere, if perhaps a little "bourgeois" in conception. He also painted some justly famous portraits, such as the *Chancellor Morone* (Duke Gallarati-Scotti Collection, Milan), remarkable both for the vigor of the treatment and its masterly design. In fact he had not only a personality differentiating him from his Leonardesque Milanese contemporaries, but also a turn of mind resembling Holbein's.

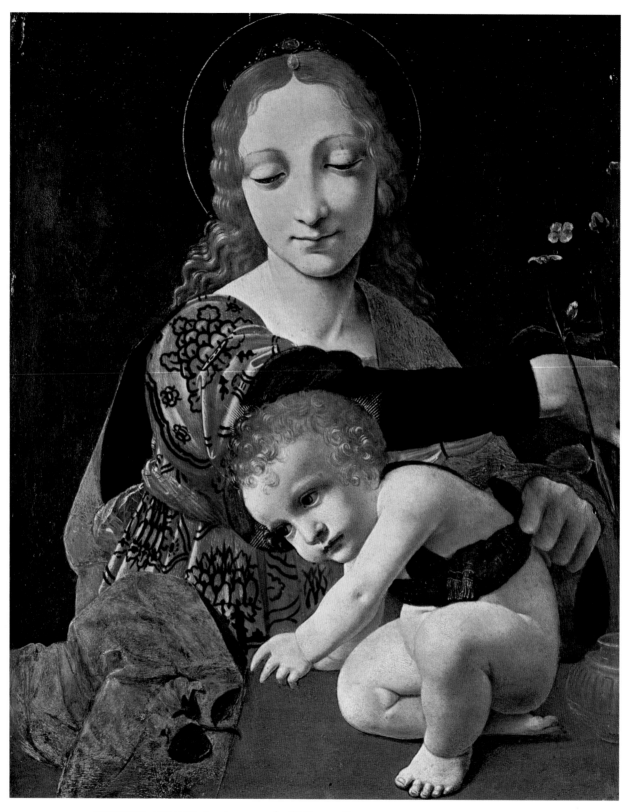

GIOVANNI ANTONIO BOLTRAFFIO (1466/67-1516). VIRGIN AND CHILD, 1490-1500.
(18 × 14 ¼″) MUSEO POLDI-PEZZOLI, MILAN.

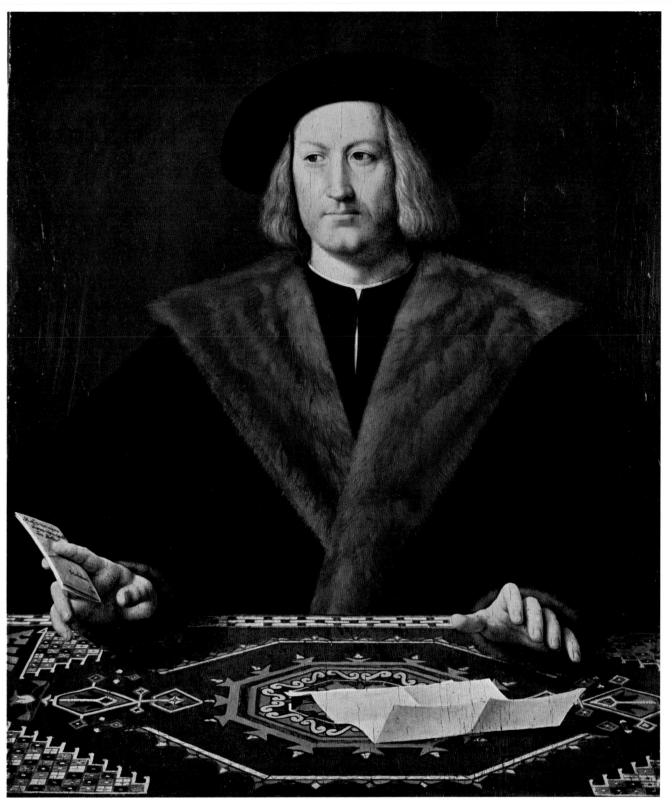

ANDREA SOLARIO (OP. 1493-1524). PORTRAIT OF CHANCELLOR MORONE, CA. 1522.
(32 ¼ × 24 ¾″) COLLECTION OF DUKE GALLARATI-SCOTTI, MILAN.

Bartolomeo Veneto (op. 1502-1530) liked to describe himself as stemming from both Venice and Cremona in equal proportions. After painting in the manner of Giovanni Bellini he moved on to a Lombard style in which, besides Leonardo's influence, we seem to detect that of Raphael and Dürer. His most successful works were portraits, which while somewhat resembling Solario's have greater elegance and a more aristocratic grace.

Like Veneto, Bernardino Luini (op. 1507-1532) combined Foppa's tradition with the Venetian procedures of Cima da Conegliano and Alvise Vivarini. It is their slightly outmoded sweetness, delicate and unassuming, and an almost childish grace, that make his best works such as the La Pelucca frescos (now in the Brera, Milan) so attractive. Here it is evident that Luini was his simple self, uninfluenced by Leonardo. Yet even his much praised "grace," long regarded as the fine flower of the Lombard soul, tends to sickly-sweetness whenever Leonardesque sophistication enters into it.

Giovanni Antonio Bazzi, better known as Sodoma (1477-1549), studied from 1490 to 1497 in Spanzotti's *bottega* at Vercelli. However, his earliest dated works—produced at Siena soon after 1500—show the Leonardesque tendencies then prevailing at Milan; hence the general belief that Sodoma spent the last three years of the century in that city. All that is best in this artist derives from Leonardo, as can be seen in his *Christ at the Column* (Pinacoteca, Siena) and *St Sebastian* (Uffizi). On the other hand, when he attempted to imitate Raphael, as in the Farnesina frescos (Rome), he never got beyond a superficial mannerism. For he lacked the insight needed to perceive the true secrets of Raphael's art, its harmony and ordered beauty.

Less refined and more spontaneous was Gaudenzio Ferrari (ca. 1471-1546), whose masterwork is the fresco sequence in the church at Varallo, near Novara. Trained at Milan, he familiarized himself with the methods of Bramantino and Leonardo, but his natural bent was towards a more popular type of art, realistic, verging on the Baroque. Nevertheless the immediacy of his responses, his practice of interpreting biblical incidents in terms of contemporary life (the Vercelli *St Christopher* is a case in point), his ingenious fusion of painting and sculpture (as in the Sacro Monte Chapel at Varallo) and, lastly, the liveliness of his color unclouded by *sfumato*—all these highly personal traits entitle him to a place apart in the annals of 16th-century Lombard painting. Indeed, given his temperament and his anticipations of Baroque, he might almost be styled a Rubens in advance of his time.

When reference is made to the "School of Leonardo," we think primarily of Lombard painters, but the Florentines, too, were much influenced by Leonardo—it might even be said that the true purport of his art was better understood in Florence. None the less there is no denying that "Leonardism" lasted longer in Lombardy than in Florence, where very soon it paled before the rising star of Michelangelo.

Florentine painting of the Quattrocento owes its greatness to a uniquely successful combination of tireless brainwork with strongly felt emotion. But after the deaths of Lorenzo the Magnificent and Savonarola its emotive drive tended to peter out, whereas the intellectual factor more than held its own—with the result that there was a gradual decline of the moral purpose in Florentine art.

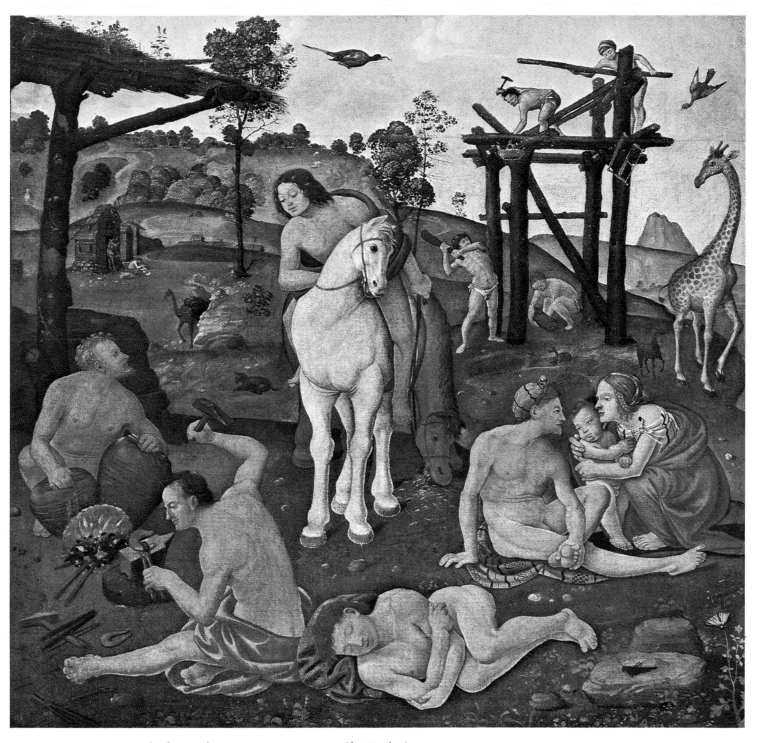

PIERO DI COSIMO (1462-1521). VULCAN AND AEOLUS. (61⅜ × 65″) NATIONAL GALLERY OF CANADA, OTTAWA.

Piero di Cosimo (1462-1521) stood outside the main current of Florentine painting in the 16th century, since in the great majority of his works the guiding spirit is obviously that of Quattrocento art. Though his debt to Leonardo is unmistakable, he cannot

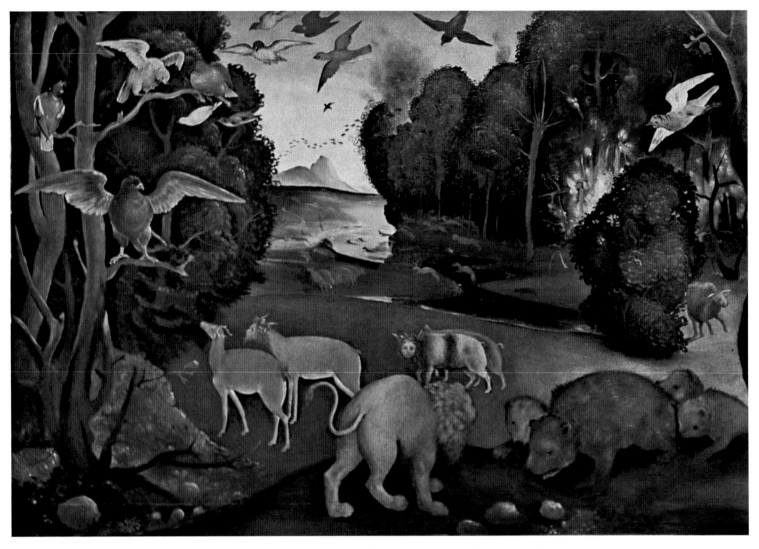

PIERO DI COSIMO (1462-1521). A FOREST FIRE (LEFT SIDE), 1490-1500.
(OVER-ALL DIMENSIONS: 28 ×80″) ASHMOLEAN MUSEUM, OXFORD.

be regarded as a disciple or a mere epigone of the master; rather, he is a painter who, defying classification, opened vistas on the future. For he displays incomparable maestria in reconciling the facts of visual experience with the fantastic inventions of his prolific imagination and in co-ordinating the technique of Leonardo with his own creative impulse, based on an exceptional feeling for, and understanding of, the archetypal myths of remote antiquity.

His originality lay in his interpretation of these themes; nothing quite like this had been done before. Breaking up outlines, he achieved effects of light and shade rarely if ever found in the work of his Florentine contemporaries. His was a strikingly unorthodox approach; hence Vasari's allusion to his "bizarre type of mind." If his last works be excepted, we might say he demonstrated in his art an alternative to mannerism. For instead of starting out from a pre-selected group of forms, he had

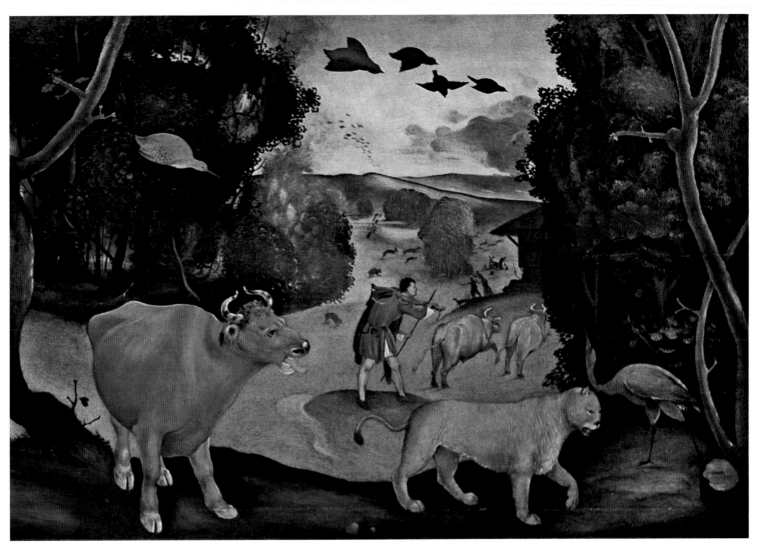

PIERO DI COSIMO (1462-1521). A FOREST FIRE (RIGHT SIDE), 1490-1500.
ASHMOLEAN MUSEUM, OXFORD.

recourse to a world of fantastic imagery imbued with the sensuality which is one of his distinctive traits. And we can easily understand why our present-day surrealists voice an unqualified admiration of Piero di Cosimo.

A born colorist, a subtle and ingenious craftsman, with a gift for rendering poetic images with meticulous precision, he created imaginary landscapes in a singularly delicate technique. Examples are *A Forest Fire* (Ashmolean, Oxford), the *Death of Procris* (National Gallery, London) and the *Venus and Mars* (Berlin). That he was also a fine portraitist is proved by the two Amsterdam portraits. While following in the footsteps of the greatest Quattrocento painters, he also mastered the use of Leonardo's *sfumato*, adapting it both to the rendering of form and to elegant, discreetly subdued expression, as in his *Magdalen* in Rome. Yet one almost feels that this artist came too late; that his age lacked the spiritual maturity needed to sustain such splendid gifts.

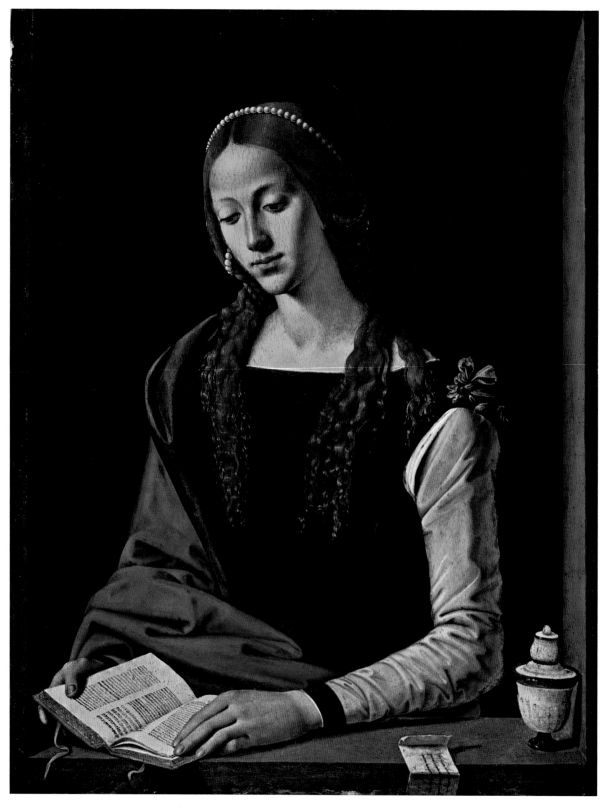

PIERO DI COSIMO (1462-1521). PORTRAIT OF A FLORENTINE LADY AS ST MARY MAGDALEN, CA. 1505.
(28½ × 21″) GALLERIA NAZIONALE, ROME.

This may be why after taking refuge in a world of fantastic imagery of the kind we should nowadays describe as "surrealistic," he relapsed into a humdrum art and confined himself to unoriginal, pseudo-monumental forms.

Two Florentine painters, Fra Bartolomeo and Andrea del Sarto, may be described as victims of Leonardo's art; both were highly gifted men and both for one reason or another failed to "make the grade" one would have expected of them.

Soon after the tragic end of Savonarola (1498), to whom he had been greatly attached, Fra Bartolomeo (1475 ?-1517), a man of a naturally pious disposition, took monastic vows. Conceived on a small scale and sensitively rendered, his early works fell in line with the Quattrocento tradition, while their forms and colors were perfectly in keeping with the religious zeal inspiring them. Unfortunately, however, the times were not propitious for the expression of a belief so zealous and sincere as that of Fra Bartolomeo; it might almost be said that the devoutness behind these early works

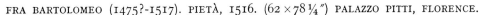

FRA BARTOLOMEO (1475?-1517). PIETÀ, 1516. (62 × 78 ¼ ") PALAZZO PITTI, FLORENCE.

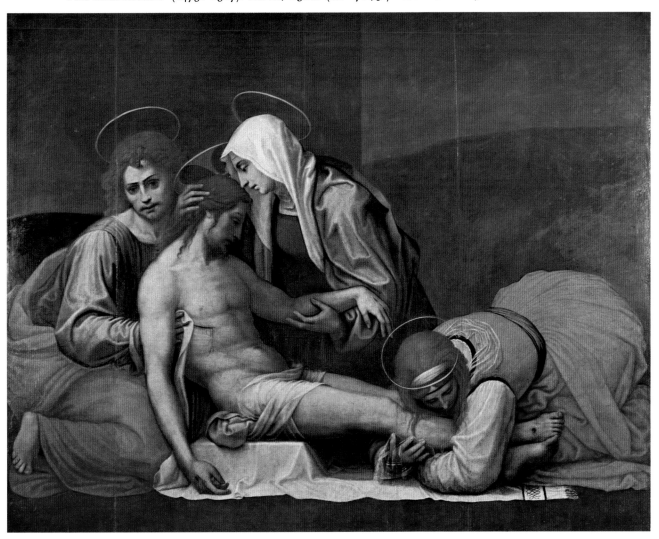

37

handicapped the artist. Like Savonarola, Fra Bartolomeo could be described as a victim of his age even though, instead of being burnt at the stake, he was loaded with honors. Being a painter born as well as a devout Christian, he could not fail to utilize Leonardo's great discovery. But *sfumato* was not intended for the expression of religious emotion, and, moreover, it led inevitably to what was known as *sprezzatura*, to architectonic composition and monumental effects more appropriate to secular than to Christian imagery. Hence the ambivalence we feel in Fra Bartolomeo's later work. The bright colors of his youth were overcast by chiaroscuro, while in many cases the free expression of his faith was sacrificed to studied monumentalism. Still there are some exceptions. The *Pietà* in the Pitti Palace, Florence, is a complete success, monumental without being rhetorical; its form is flawless, its emotion sincerely felt, nor does the *sfumato* devitalize its color. Only one objection might be made to this otherwise perfect work: the sepulchral coldness pervading the composition and making it look like an array of statues in tinted marble. Fra Bartolomeo's tragedy was that of a man who was not strong-minded enough to react against the culture of his age, and at the same time too scrupulous to compromise with it.

The problem of Andrea del Sarto (1486-1531), on the other hand, was not one of choosing between religious faith and the spirit of the Renaissance. He was a natural colorist, much more so than Fra Bartolomeo; yet he, too, thinned his color by an admixture of *sfumato*. It might be argued that, as a by-product of light and shade, *sfumato* can but intensify color. But the fact remains that Leonardo employed it as a means of rendering form and chiaroscuro, and it could never be transformed into those effects of light and shade produced by color *per se*, as found for instance in Venetian painting. Monumental and dynamic, Andrea del Sarto's form implements a composition that holds well together plastically and has great expressive power. For three centuries he ranked as one of the greatest Italian artists; today he has but few admirers. Vasari, perhaps, put his finger on the explanation when he said his art was "flawless." So long as writers on art set an overriding value on craftsmanship, Andrea was praised to the skies; but when stress came to be laid on the artist's "message," our flawless painter was dismissed as tedious. His method of handling color can be seen to advantage in the *Assumption* in the Pitti Palace. A patch of *sfumato* in the center at once gives a sense of depth and acts as a foil to certain colors—red, yellow, olive-green—which float on the surface without being eaten up by the chiaroscuro. Whereas in his famous *St John* (also in the Pitti) the beauty of the colors is marred by an over-emphasis on sculpturesque values, giving a curious lividity to the ensemble. In *Charity* (Louvre) the pyramidal structure is highly effective, vibrant like a tongue of fire, and one gets the feeling of an ingenious contrapposto between the figures which seem to be sinking down and the ascending drive of the plastic lines of force. Better perhaps than any of his coevals, Andrea del Sarto understood the nature and potentialities of Leonardo's *sfumato* and grasped the many opportunities it provided for experiments in style. But, little daring, he aspired to nothing higher than mere formal perfection. Thus he was the type figure of the virtuoso *à outrance* — a perfectionist too perfect to be "alive."

Though not born in Florence, Raphael and Michelangelo were trained there and so belonged to that Florentine school which held the lead in Italy for two centuries thanks to its boldness, intellectual range and active interest in all the art problems of the age.

Urbino, Raphael's birthplace, would have been little more than a drab provincial town remote from the art currents of the day had not Duke Federigo da Montefeltro converted it into a flourishing cultural center. The Ducal Palace, designed by Luciano Laurana, was originally decorated by Piero della Francesca, Uccello and Joos van Ghent; later, by Melozzo da Forlì, Luca Signorelli and other celebrated artists. No less famous than its art treasures was the splendid library, one of the largest in Europe. Renowned for its elegance and erudition, Federigo's court provided a model for one of the most famous books of the Renaissance, Baldassare Castiglione's *Il Cortegiano* ("The Perfect Courtier"), published a generation later. That under the enlightened sway of a man like Duke Federigo this relatively obscure Italian town should have blossomed out into a center of art and learning need not, given the conditions of the age, greatly surprise us. The remarkable thing is that Urbino should have promptly given the world two artists of the very highest rank: Bramante and Raphael.

Raphael's father was a painter and a poet of no particular merit, but it is to his credit that he sensed the greatness of Leonardo and Perugino from the start. Raphael, who was only eleven when his father died in 1494, was sent to study under Perugino in the last years of the century, and took a hand in the decorations of the Sala del Cambio at Perugia, which were completed in 1500. Like Leonardo, Perugino had studied under Andrea del Verrocchio but, unlike him, had failed to realize the importance henceforth to be attached to movement, plastic vigor and monumental composition. On the contrary, he practised an art imbued with religious emotion in which woman's beauty and the glamour of remote horizons played a leading part. Despite his success in Florence he preferred to retire to the country, where he became the moving spirit of the so-called Umbrian School.

At the Court of Urbino young Raphael had daily opportunities of feasting his eyes on the most refined achievements of contemporary art. Meanwhile his teacher Perugino instructed him in the expression, on traditional lines, of both physical beauty and a grace instinct with deep religious faith. So well did he assimilate his master's methods that, in his early phase, it is no easy matter distinguishing his work from Perugino's. However, in some of his smaller pictures he brings to Perugino's compositional schemes a beauty so novel and so richly colorful that their forms are changed out of recognition. The themes may be the same, the spirit is quite different. Raphael's beauty is too graceful to be sensual, adapted even to the expression of religious sentiment, and, though containing no radically new elements, diverges from the tradition of the previous century. Thus, out of the blue so to speak, there came into the world a well-nigh peerless painter, dedicated heart and soul to his ideal of beauty, an ideal he kept before him even when his style underwent a change. And Raphael's conception of the *beau idéal* held unchallenged sway throughout Europe for three centuries and more, as being the very acme of perfection.

RAPHAEL (1483-1520). ST MICHAEL, CA. 1502. (12 ⅛ × 10 ½″)
LOUVRE, PARIS.

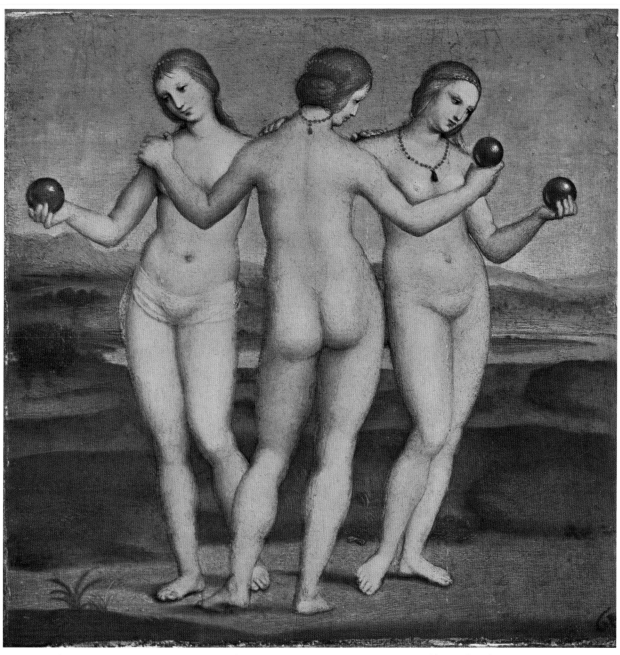

RAPHAEL (1483-1520). THE THREE GRACES, CA. 1500. (6⅝ × 6⅝″)
MUSÉE CONDÉ, CHANTILLY.

The small pictures referred to above are the *Vision of a Knight* (National Gallery, London), the *Three Graces* (Musée Condé, Chantilly) and the *Madonna del Conestabile* (Hermitage, Leningrad). The "Vision of a Knight" is the romantic title which has been foisted on a picture that probably represents Hercules with Virtue and Vice competing for his favors. We may assume this picture to be earlier than the other two, since it shows signs of technical inexperience, indeed a certain awkwardness—qualities which, however, far from impairing it, lend it a special charm. It might well be the fantasy

of a precocious child artist who has imparted, by some artifice of innocence, the wistful loveliness of a dream of spring to the figures, landscape and tapering tree, the slender axis of the composition. In the *Three Graces* some have thought to see the reproduction of a sculptured group or an ancient seal. But surely it is clear enough that Raphael was not "reproducing" anything; on the contrary, he created a rhythmic, very slightly plastic linear composition in which the figures of the three women are outlined, all on the surface, against the sky—three presences of a delicate loveliness miraculously arising, as if conjured out of air, against a distant landscape background. The composition of the *Madonna del Conestabile* is more elaborate, the figure being inscribed within a circle limiting the spatial planes and tightening as it were the affective link between the Mother and the Son, while the distant scene seems like the landscape of a dream.

These three pictures are so unlike anything by Perugino that it has been suggested that, before going to Perugia, Raphael may have studied in the *bottega* of Timoteo Viti, and thus familiarized himself with the glowing color of Ferrarese art. But for one thing, it seems unlikely that Raphael would have found anything to inspire him in the work of that drearily mediocre painter, Viti; also, we must take into account his boyhood at Urbino and the countless opportunities he there had of seeing some of the best work of the day. One thing is certain: in the subtle difference between the three early works in question and the art of Perugino we can discern the distinctive traits of Raphael's personality: the sweetness and tranquil beauty which were to be the constants of his art.

They were painted, it would seem, around 1500. Three years later came the *Coronation of the Virgin* in the Vatican, where is also the *Madonna enthroned between Saints* painted by Perugino some five years before; and it is interesting to compare the works of master and pupil. Raphael's picture is all disarming loveliness and smiling grace, and forms are brought out by the brightness of the colors. Perugino's composition has more vigor and formal solidity, while the distribution of bright and dark areas and of the colors is much more carefully contrived. It cannot be denied that beauty alone does not suffice to make a noble work of art; something more is needed, an ordered coherence between the various elements of which the picture is composed. Viewed from this angle, Raphael's painting is defective. Though the *Coronation of the Virgin* is a relatively small composition, it is none the less too large; the gemlike colors which were so effective in Raphael's small pictures seem lost in the wider expanse of an altarpiece. Also, the charm of figures devoid of any psychological pretensions ceases to operate when the painter seeks to emphasize the poignant grief of the apostles gazing at the Virgin's empty tomb. Finally, there is no denying a certain awkwardness in the visual relationship between the celestial and terrestrial figures: the problem so ably solved by Perugino in his *Virgin in Glory* (1500, Uffizi). Reasons for the failure of the *Coronation* altarpiece are the painter's inability to mask the contrast between "presentation" and "representation" and, secondly, his use of a technique unsuited to works of large dimensions. We can see the difference in the small paintings of the predella which have a lightness and a spontaneity of movement not merely illustrating action but bringing the scene as a whole to life.

Here, then, we find a distinct advance on Raphael's 'prentice work; he has mastered a new element of his art, the rendering of movement, and this, too, he attunes to beauty, always his supreme concern. In the predella there is no longer any clash between the dainty elegance of the representation and the dimensions of the picture surface. Raphael, in short, has found himself.

The rapidity with which his art matured is proved by the *Marriage of the Virgin* (Brera, Milan), dated 1504. In this picture Raphael fell back on a lay-out used by Perugino for the same subject in a work commissioned in 1499 and not yet completed in 1503 (Caen Museum). But he excelled his master both in the general effect and in the perfection of the parts. Perugino failed to convey so fully the feeling of apparent space as created not only by perspective projection but also by the grouping of figures and the strictly geometric volumes of the temple. By now Raphael had learnt all he could from his teacher, whose limitations he all too clearly saw. It was time to strike out on a new path, and in 1504 he moved to Florence, "to learn more," as Giovanna Felicia Feltria announced in a letter introducing the young painter to Pier Soderini.

Once in Florence Raphael soon discovered that Perugino was outmoded, a survival from the Quattrocento; for a young painter, keen-eyed and forward-looking, Florence spelt Leonardo and Michelangelo. What has been called his Florentine style took form between 1504 and 1508. This does not mean that he spent all his time in Florence (actually most of his painting was done at Perugia), but that Florence was for the nonce his "spiritual home." Nevertheless he did not imitate Leonardo or Michelangelo, though he must have watched with excited interest the progress of their work in the Palazzo Pubblico. But he never desisted from his quest of beauty, of perfect craftsmanship and of that *sprezzatura* which was his lifelong ideal. In exploring new fields, he kept for a while to the motifs of his former teacher. But although still appearing in his *Ansidei Madonna* (1505-1506, National Gallery, London), these motifs are recast with an eye to the unity of a composition truly monumental in conception. In the *Marriage of the Virgin* the relationship between figures and background had been more of a narrative than of a visual order, and the former, generally darker than the architectural setting, were out of tone with the ground. But in the *Ansidei Madonna* a color dynamism of a special kind, expressed in terms of masses, is generated by the relationship between the dominant brown of throne and figures, and the blue-grey architecture. Here it is evident that Raphael had grasped Leonardo's synthetic handling of forms, though without as yet employing the *sfumato* which was its corollary. But in the *Madonna del Gran Duca* (Pitti Palace) he has perfectly assimilated it. A uniform dark background enables him to make the figures stand out sharply and they are rendered with a sensitivity lacking in his earlier work, which gives them at once the elusive spirituality of heavenly apparitions and the tactile values of solid bodies. For Raphael does not, like Leonardo, allow his *sfumato* to envelop forms modeled in relief but cuts it short where they begin. Thus he succeeds in investing the object represented with the grace of formal abstraction without sacrificing the actuality of visual experience, while the gleaming colors of his early phase dwindle into monochrome.

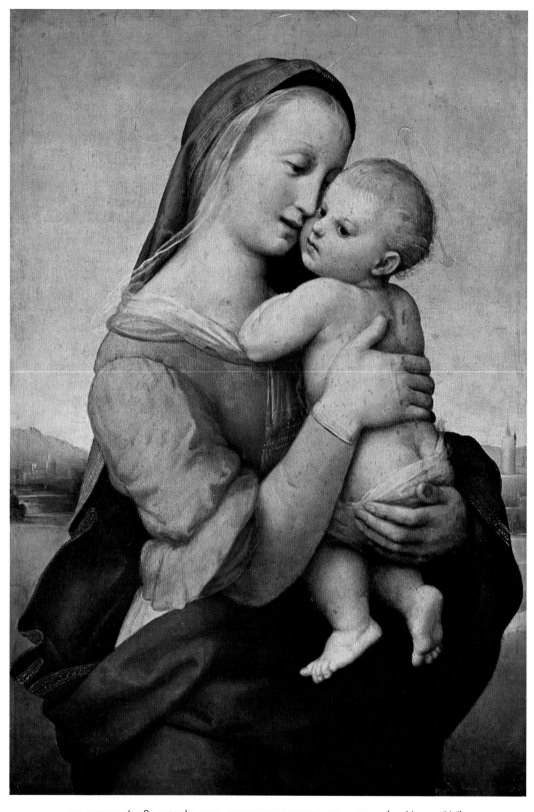

RAPHAEL (1483-1520). THE TEMPI MADONNA, CA. 1505. (29½ × 20½″)
ALTE PINAKOTHEK, MUNICH.

This abandonment of the faintly sensuous beauty of his *Madonna del Conestabile* and the blandishments of color was Raphael's tribute to the spirit of Florentine culture.

The *Madonna del Gran Duca* did much to consolidate his fame. The works he now produced were universally accepted as flawless paradigms of beauty, even in cases where his personality made itself less felt and the results fell short of his highest standard. But into the *Tempi Madonna* (Munich) he put the best of himself. The perfection of the forms somehow heightens our sense of the bond of deep affection between the Mother and Son, while the movement linking them together and the harmony of the dark tones against the sky redeems the conventionality of the pyramidal composition and an over-emphasis on sculpturesque values.

The world-famous prototypes of female beauty Raphael created in this second or Florentine period—the *Madonna del Prato* (Vienna), the *Madonna del Cardellino* (Uffizi) and the *Belle Jardinière* (Louvre)—have very similar settings. The figures are placed in open country against one of those low, remote horizons that Perugino also favored. The Madonna is watching her Son or the child St John at play, sometimes speaking to them. All three Madonnas look like portraits of exceptionally handsome young women, done from the life—so much so that one almost feels the models are posing to display their charms. Raphael had certainly seen Leonardo's *St Anne*, but he deliberately shut his eyes to the spiritual implications of his elder's style and also to the suggestive power of a judicious unfinish. He aspired to something else: a completely realized plastic beauty in which the figures had both material volumes and at the same time a significance more real, more valid than that of their earthly existence. Raphael, in a word, transmuted Leonardo's grace into beauty. The three works named above are perfect of their kind, but when we turn to the *Portrait of Maddalena Doni* (Pitti Palace, Florence) we perceive Raphael's limitations. Patently inspired by the *Monna Lisa*, the figure is too massive, too static, and there is something at once superficial and uninspired about the presentation. What was superficial in Raphael's early work was not his response to beautiful things but his response to life in general. Once he had grasped the principles behind Leonardo's modeling in paint, he made the most of them. But he was careful not to venture outside this field, in which he felt himself secure. Thus it is only natural that those who prefer the perfectly ''finished,'' self-contained work of art to one that opens vistas on infinity should find Raphael more satisfying than Leonardo. Nor need we be surprised if, in his quest of form devoid of any vagueness, he discarded Leonardesque *sfumato* and was, rather, drawn towards the acknowledged master of fully plastic form and sculptural effects: Michelangelo.

When Atalanta Baglioni, ''whose eyes had no longer tears enough to weep for her son's crimes and the vengeance of her kinsmen,'' asked Raphael to paint a *Deposition from the Cross* (1507) in which her own sorrows were reflected in those of the Mother of the Crucified, he began by sketching out a composition in the style of Perugino, full of tragic pathos. But after a while he thought better of it and instead of bearing in mind the grief of the bereaved mother or even his own inclinations, he decided to use this picture as a pretext for displaying his familiarity with classical antiquity and the

technique of Michelangelo. Thus he made much of the dramatic elements, stressing the tensions of figures and, preoccupied with the harmony of attitudes and gestures, relegated to the background the group of women beside the swooning Virgin. Also, he lingered too long over details, to the detriment of emotional drive and imaginative freedom. How different were the small pictures of his early youth, all charm and spontaneity! It now was clear that, if he was to regain that first fine rapture, he must no longer seek his models in antiquity or the grandiose art of Michelangelo, so foreign to his temperament. For his personal vision was entirely different, poetic and inspired by naïvely Christian piety.

The 1507 *Deposition* (Borghese Gallery, Rome) proved that Raphael was no longer a provincial artist, but had thoroughly mastered all the technical accomplishments of Florentine art at its most expert and sophisticated. But three conditions had yet to be fulfilled before he could make good his personality and emancipate himself from the influences of his early training. First, he had to acquire more ease of execution, so that perfection came quite effortlessly; secondly, to substitute poetic contemplation for dramatic action; and finally, an occasion had to arise impelling him to get every ounce out of himself. And in the fall of 1508 the Stanze of the Vatican opened their doors to him.

The Stanze where Raphael now was called to work consisted of a series of rooms above the Appartamenti Borgia in the Vatican. In October 1508 a team of painters, amongst them Sodoma, Bramante and Lotto, was still engaged on decorating them and traces of their paintings still survive on the vaults of the Stanza della Segnatura. But they soon ceased working and Raphael undertook to decorate the walls, single-handed—a task on a far larger scale than any of his previous ventures.

The fresco wrongly called the *Disputa* actually depicts the "Triumph of Religion." The cause of the misnomer was the fact that the persons represented, saints and doctors of the church, are involved in a fervent debate—certainly not a "dispute"—concerning the Eucharist. The theme here is theology, while that of the so-called *School of Athens* on the opposite wall is philosophy (in its widest sense, including the sciences of ancient Greece). The frescos on the other walls celebrate poetry (Mount Parnassus) and the rule of justice (Jurisprudence) respectively.

Theology, philosophy, poetry and justice bulked large in Renaissance culture and Raphael was supremely successful in clothing them in pictorial form; hence, perhaps, the reason of his immediate success. Pope Julius II and all the cultivated members of his entourage saw in these frescos a reflection of their deepest aspirations; indeed this set of frescos might be described as an apotheosis of the cultural ideal of the Renaissance. In an apotheosis rhetoric is indispensable and one of Raphael's gifts was that of giving rhetorical effects a liveliness and spontaneity—not to say naïvety—that freed them from any trace of the pomposity and stiffness too often found in such works, and of transmuting rhetoric, by means of *sprezzatura*, into poetry. Propounded by Raphael's friend Baldassare Castiglione, *sprezzatura* (unconstraint) bore out the dictum *ars est celare artem* since it meant interpreting emotion by way of natural, graceful gestures, without any unseemly emphasis on expressive elements.

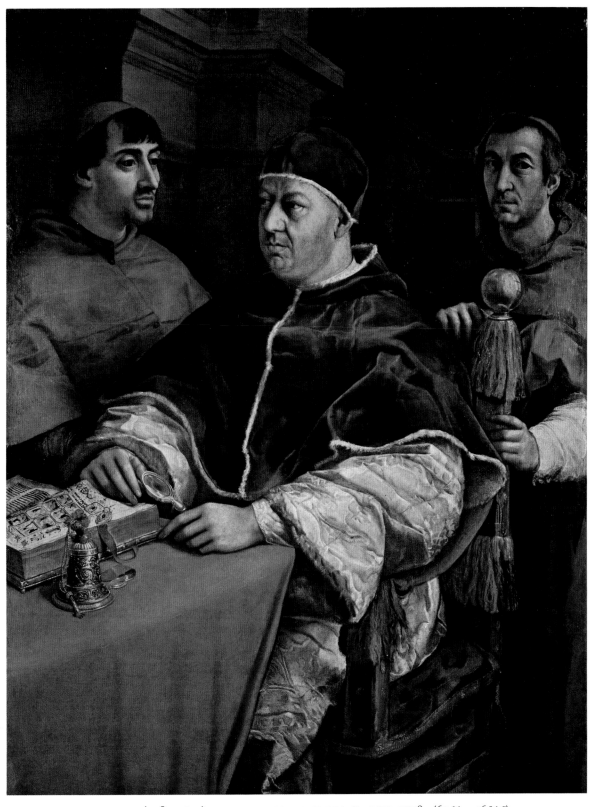

RAPHAEL (1483-1520). PORTRAIT OF POPE LEO X, 1517-1518. (60½ × 46¾″)
UFFIZI, FLORENCE.

RAPHAEL (1483-1520). PORTRAIT OF POPE LEO X (DETAIL), 1517-1518.
UFFIZI, FLORENCE.

The setting Raphael gave this vision of the several aspects of Renaissance culture was of a kind he had not hitherto employed: an ideal architectural complex. When studying under Perugino, he had familiarized himself with the rendering of far horizons and vast open spaces, symbols of the infinite. But in the *School of Athens* space is given a new significance; the architectural elements are no longer mere décor, but functional to the structure of the picture—an innovation which, thanks to Raphael, affected all the subsequent painting of the Italian Renaissance. It is quite otherwise with the *Disputa*. True, we have here a perspective in depth that indicates the relationship between the divine figures and the human elements: popes, cardinals, jurists and poets. But brilliant as is the handling of space, this picture still conformed to the tradition of the many "Coronations of the Virgin" in which the relations between heaven and earth had been conveyed on very similar lines.

RAPHAEL (1483-1520). PORTRAIT OF POPE LEO X (DETAIL), 1517-1518.
UFFIZI, FLORENCE.

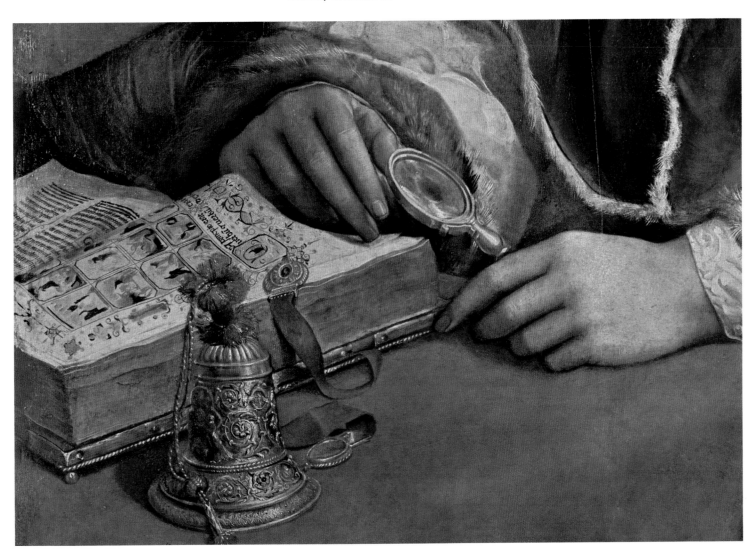

The use of this traditional conception of space enabled Raphael to devote his whole attention to figures and their attitudes. As early as the 18th century it was pointed out that Raphael does not represent "completed actions." He recorded movement at the moment of its inception, not when it had been completed and was, therefore, of the past. Obviously an incipient movement conveys the play of feeling far better than would a presentation of the figure in repose; hence the agitation pervading the scene of the *Disputa* and also the dance-like rhythms of the *Parnassus*. In the latter fresco the figures, distributed in groups, are all remarkably beautiful; indeed all of Raphael's figures, even white-bearded patriarchs, seem endowed with eternal youth.

Judiciously restored, the *Disputa* has now regained its pristine brightness and we can admire the delicacy and aptness of the coloring, which at once defines forms and contributes to the organization of space. But here neither the color nor the light is adequate to create, by itself, the illusion of actual three-dimensional space. Light does not absorb the figures; rather, the contrary is true. In the *Disputa* the figures are dark, standing out on a bright ground—which theoretically should ensure the maximum pictorial effect; but Raphael failed in this because he paid too much attention to the local chiaroscuro of each figure. The scene of *Gregory IX presenting the Decretals to St Raymond of Penafort* is the first fresco in which Raphael faced up to this problem unequivocally and stressed the function of color. And in so doing he gave a new development to the technique employed in the *Ansidei Madonna*.

Nevertheless he felt a desire to go still further and to create by means of color-light a more intimate relationship between figures and their setting. This he did in the *Mass of Bolsena* in another of the rooms. Here at first glance we can see that the spatial architecture of the *School of Athens* has given place to construction in terms of color. The lights and shadows of the church build up a setting for the forms which they envelop even in the foreground, beyond the big bench acting as a sort of backdrop, in front of which the altar bathed in light at once spaces out and sets off the dark-toned figures. Saturated with light, the colors acquire a glowing sheen not found in the work of any other painters of Central Italy. But beauty of color and perfect integration of the figures into their setting are not the only virtues of this noble fresco; thanks to Raphael's new vision those slightly rhetorical effects which still obtained in the commemorative decorations of the Segnatura are here eliminated. What gives this picture of a miracle that had taken place at Bolsena in 1264 its lifelikeness is its presentation in "modern" garb, as an incident occurring at the Vatican in the presence of Pope Julius II, his attendants, the Swiss Guards, and some handsome Roman women. Thus his desire to pay homage to the pope, his patron, led to one of Raphael's finest works; moreover in the group of Swiss soldiers we have a wholly admirable synthesis of Florentine and Venetian technique. Perugia, Florence and Rome had played their part in enabling Raphael to realize his dream of an ideal beauty; this new conception of color *in excelsis* was transmitted to him, with Sebastiano del Piombo, Lorenzo Lotto and the Dossi as intermediaries, by Venice, where Giorgione now was pointing the way to a whole new world of art.

The *Mass of Bolsena* figures in the Stanza d'Eliodoro, so named after the fresco representing the *Expulsion of Heliodorus from the Temple*. In the same room are the *Liberation of St Peter* and the *Meeting of Leo I and Attila*. These were executed between 1511 and 1514, and as Julius II died in 1513, the last wall was painted under the auspices of Leo X. This change impaired the unity of the ensemble. Julius II had wished the Stanza della Segnatura to celebrate his civil and religious ideal, and this second room to illustrate his victories. The *Expulsion of Heliodorus from the Temple* commemorates the pope's victory over the Venetians who had occupied a portion of the States of the Church. The *Mass of Bolsena*, in which a miracle convinces a doubting priest of his error, symbolizes the pope's triumph over the cardinals who had proposed to hold a Council at Pisa with a view to deposing him. The *Liberation of St Peter* recalls the incident when the pope was almost taken prisoner at Bologna, while in the *Meeting of Leo I and Attila* Julius II wished to remind beholders that just as Leo I had forced the barbarians to retreat, he, Julius, had averted the risk of a foreign invasion.

Unlike the symbolic decorations of the first Stanza, the subjects Raphael had now to deal with were historical events. In the *Mass of Bolsena* he had succeeded in transmuting an ancient legend into a scene of contemporary life, and had produced a masterpiece. Still he could not always work with the same fervor and in the *Expulsion of Heliodorus*, notwithstanding the beauty of the temple shown in full perspective and the light falling on the pope in prayer, we cannot help being conscious of Raphael's failure to achieve the dramatic effect he was aiming at. The amply molded forms, derived from Michelangelo, and the impetuous movement of the group including Heliodorus do not suffice to create an atmosphere of drama. And despite the balanced presentation of Julius II and his troops, the composition does not hold together. The *Liberation of St Peter* is a technical feat, and its violent contrasts of light and shade anticipate some of the procedures of Baroque art. Raphael had not only an almost uncanny gift of prescience but an equally amazing facility of invention; here he brings off effects of which, only two years earlier, he would never have dreamed. But it is essentially a virtuoso performance, fruit of an imagination more spectacular than creative.

Lastly in the *Meeting of Leo I and Attila* Raphael displays so little interest in the style that he seems to have quite forgotten his discoveries in the field of color and even in the rendering of space. Massed on the surface of the composition, horses and their riders are little more than illustrations of an historical event. Poetry and dramatic action alike are absent, and elegance is the painter's chief concern—Renaissance art is giving place to Mannerism.

Some of Raphael's larger portraits anticipate, or keep closely to, the style given such masterly expression in the *Mass of Bolsena*. Earliest, perhaps, is the portrait of Julius II (Uffizi), in which the artist brings out clearly the character of his model: quick-tempered, bursting with energy, always ready to leap to action and enforce his iron will. Here the painter's easy mastery of his medium is no less striking than his psychological insight. In a sense this portrait is dramatic, but here as always Raphael's sense of the dramatic found expression solely in potential not in overt action.

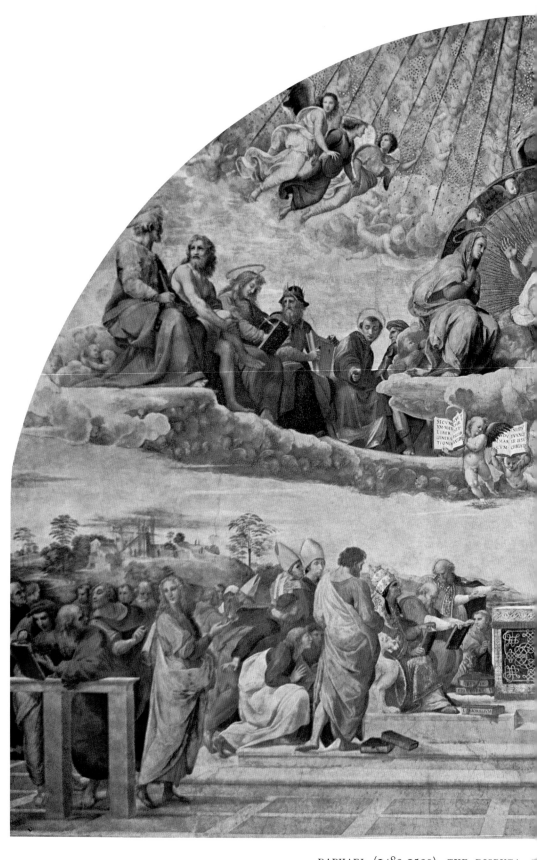

RAPHAEL (1483-1520). THE DISPUTA,

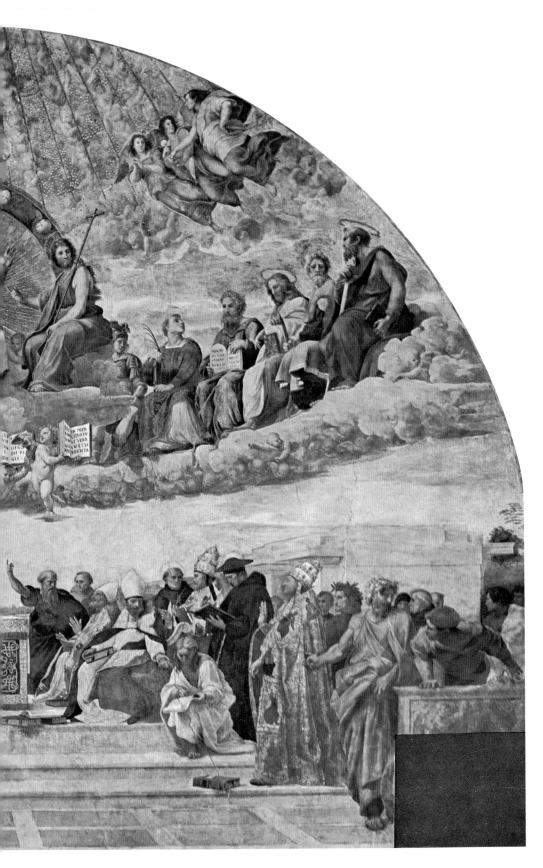

CO, STANZA DELLA SEGNATURA, VATICAN.

Very different is the *Portrait of a Cardinal* (Prado), an essentially poetic study of a face. The beauty Raphael aspired to give it was not merely personal or formal but also in its implications, the sublimity of its patrician refinement, almost the aloofness of a demigod. Even the scarlet of the cardinal's cloak—both intense and restrained in tone—seems invested with an aristocratic elegance exceptional even in Raphael's work. And we are tempted to see in this a spiritual self-portrait, the most authentic image of himself the painter has bequeathed to us. If this be so, it corroborates what Vasari has to tell us about Raphael: "Whenever he went to the court he was escorted by fifty young painters, all highly gifted, a sort of royal retinue. Indeed he lived, not like a painter, but like a prince." This "aristocratic" quality of beauty was not confined in Raphael's art to persons of lofty rank. In his *Baldassare Castiglione* (Louvre), a portrait of the man who was described by the Emperor Charles V as *"uno de los mejores caballeros del mundo,"* the color-scheme is black-brown-grey with faint glints of gold, a complex of tonal values rather than rich hues; in fact the subdued harmony of the colors is a reflection, as it were, of the spirit of the true-born gentleman at its noblest.

Quite other is the gaze of Leo X as portrayed with his nephews Giuliano de' Medici and Ludovico de' Rossi. We cannot but be amazed at the rapidity with which Raphael's conception of the portrait had matured in the twelve years between the half-length likeness of Angelo Doni made about 1506 and this group. Pope Leo X has not the tense expression of Julius II, nor the patrician beauty of the *Cardinal*, nor the endearing amiability of Castiglione. This portrait was made to celebrate the social prestige of the pope and his patronage of arts and letters (symbolized by the illuminated book), with a certain emphasis on the fineness of the hands—on which the pope prided himself. Thus the model's strong personality makes itself felt amid a number of extraneous elements—which may imply that the artist was less in sympathy with him. In any case, however, this is plainly an "official" portrait.

But there was no lack of interest on Raphael's part in, for example, his painting of a handsome Roman woman of the lower classes, *La Donna velata* (Pitti). It has been remarked that the sumptuous dress looks rather out of keeping with the woman's personal appearance; it looks as if she had dressed herself up for the sitting. She has a shy, faintly puzzled gaze. "Why," she seems to be thinking, "should I be singled out for so high an honor?" Apparently Raphael found this sitter and her ingenuous air to his liking, for he used her some years later (in an idealized rendering) as his model for the *Sistine Madonna* (Dresden).

In 1511 and 1512 Sigismondo Conti, a friend of Julius II, commissioned Raphael to paint the *Madonna di Foligno* (Vatican) for the high altar of Santa Maria in Aracoeli in Rome. This work is based on the legend of the Ara Coeli, the apparition of the Virgin to Augustus. In Raphael's picture the Roman Emperor is replaced by Sigismondo Conti, who died in February 1512. Though Raphael may have begun work on the picture at the same time as the Stanza della Segnatura, he must have spent some years on it, as it is done in the new technique employed for the *Mass of Bolsena*.

The *Madonna della Seggiola* (Pitti) is one of Raphael's best-loved pictures. Here once again we cannot but appreciate the poetic glamour with which the sacred figure is invested, yet with an uneasy feeling that its spiritual quality suffers a little by the emphasis on physical perfection. None the less the happy disposition of the figure within the circle of the picture space, the plastic vigor of the forms and the color harmony compel our admiration. Red, green and yellow sing out melodiously, but their accord is purely superficial, there is no real relationship of values holding them together.

Very different was the creative inspiration behind the *Sistine Madonna* though it too was "made to order." The curtains drawn back on either side to reveal the Queen of Heaven moving forward over the clouds create a frankly theatrical effect. And equally of the theater is the gesture of Pope Sixtus commending to the Virgin the assembled congregation. St Barbara is too suave, too mannered for her beauty to come to life—but her role is only that of a supernumerary. Two small angels leaning on their elbows lighten the monumental impact of the scene. But though several of its elements may fail to move us, the picture as a whole has a singular appeal. The Virgin's movement is delightfully supple and thanks to a skillful distribution of the figures the surrounding space is at once clearly articulated and infinite in depth. Painted around 1516, this picture marks the close of Raphael's Renaissance period, though so far there is no trace of mannerism.

But, unlike the *Sistine Madonna*, the *Incendio del Borgo* in the third of the Vatican Stanze—it is the only picture in this room on which Raphael himself worked—is definitely mannerist in conception. Here the artist sought to vie with Michelangelo's nudes and stressed the elegance of the figures. Perspective is used to create the illusion of space but there is no longer any real spatial composition and the buildings represented have no constructive values. Looking at this work, which must be written down a failure, we realize that the ideal architecture, the feeling for space and the physical beauty which so delight the eye in Raphael's masterpieces are a sort of happy miracle, based in the last resort on an unstable equilibrium—all the more precarious because it relied entirely on spontaneity and an idealized sensuality. But there came a time when Raphael felt he had mastered his art from A to Z, had nothing more to learn, and when he came to regard even color as no more than an easy means of representing visual data with forcible directness. And now he aimed at imparting a new spirituality to his figures, at making them more mobile and dramatic, and at stressing relief by stronger contrasts between light and dark areas. Unfortunately his genius did not lend itself readily to this new program; what it needed was that subtle balance between the physical and the spiritual, between presentation and representation, which was universally regarded for the next three centuries as art's supreme achievement. By 1514 Raphael had ceased believing in this; what he now sought for was a form of expression less spontaneous, at once more intellectual and more fanciful. It was his vast success that brought him to this pass—and it also prevented him from carrying out his new intention. As chief architect of St Peter's, inspector of excavations and conservator of antiquities, he had hardly time enough even to design cartoons for his pupils and the

Flemish tapestry-weavers who interpreted his work at Brussels. True, he is not the only painter who ended up by letting the desire for a more "intellectual" art cramp his creative inspiration. But in Raphael's case the results were little short of disastrous, as can be seen if we compare his decorations of the third room in the Vatican with that miracle of beauty, the *Mass of Bolsena*.

Death came to Raphael when he was only thirty-seven and at the height of his fame. So potent was the spell his art had cast on his contemporaries that all alike, from the pope to the humblest of his assistants, felt that with his passing something truly divine had left the world. Yet Raphael had already crossed the summit of his art and set foot on the downward slope. He had given of his best and the hour had struck for him to quit the scene if art's impending setbacks, due to the dead hand of academicism, were not to be laid to his account.

RAPHAEL (1483-1520). THE LIBERATION OF ST PETER (FRAGMENT), 1511-1512.
FRESCO, STANZA D'ELIODORO, VATICAN.

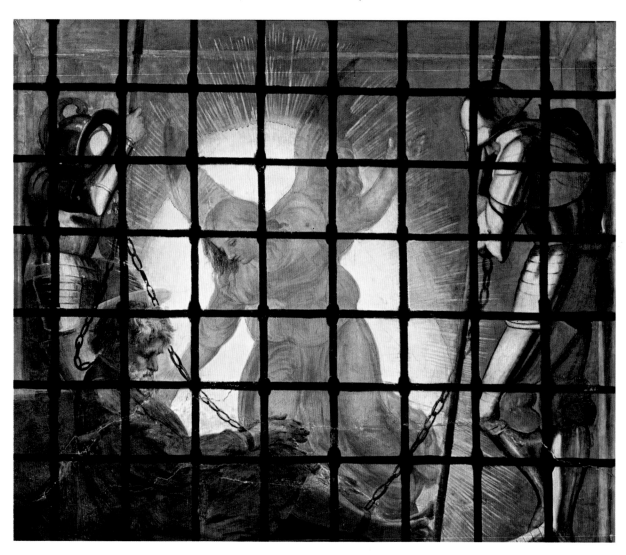

Born in 1475, Michelangelo Buonarroti was the son of a Florentine gentleman who held the office of podestà (mayor) in the small Tuscan towns of Caprese and Chiusi. He was educated at Florence and in 1490 admitted to the famous school of art established in the Medici gardens, studying there until the death of Lorenzo the Magnificent in 1492. The social standing of his family and the favor shown him by Lorenzo may account to some extent for the overweening pride so characteristic of the man and of his art.

Twenty-three years younger than Leonardo, Michelangelo reached maturity in the early years of the century when the older artist, whose rival he soon became, stood at the height of his fame. He won the confidence of Pope Julius II and was employed on large-scale works in Rome before the coming of Raphael whom, despite the influence he exercised on the younger man, eight years his junior, he came to regard as a dangerous, too successful rival. Comparing the dates of their deaths—Leonardo's in 1519, Raphael's in 1520, and Michelangelo's in 1564—we can see why their paths diverged so widely. All three had shared in the same artistic climate, that of the first two decades of the 16th century, but after the deaths of Raphael and Leonardo, Michelangelo had many long years before him for building up a body of work stamped with his unique personality and a style that was to condition European art for half a century. He lived long enough to see the end of an era, the Renaissance, and the beginning of another, that of Mannerism. When we recall the course of history in 16th-century Italy, we can imagine what it must have meant to start out as Michelangelo did in the cultured atmosphere of Lorenzo's court and, after enjoying the patronage of Julius II, to have to carve out a new career after the fall of the Florentine republic and to bow to the dictates of the then all-powerful Counter-Reformation.

Fundamental to Michelangelo's whole conception of art was the fact that he was born to be a sculptor. Yet his fame rests largely on his frescos and a *magnum opus* in the field of architecture: the paintings in the Sistine Chapel and the dome of St Peter's. When in 1508 he set to work on the Sistine ceiling, he voiced his dissatisfaction in a letter to his father: "Painting is not my profession... I am wasting my time." And in 1547, when appointed chief architect of St Peter's Church, he complained that "architecture was not his trade."

It is noteworthy that, unlike his paintings, a great many of his sculptures were left unfinished. This suggests that he painted because he was compelled to, whereas he did his sculpture to please himself; and, actually, it is in the latter that his highly individual genius reveals itself most fully.

An old tradition has it that he studied in the school of Domenico Ghirlandaio but nothing in his work bears this out. It was from ancient statuary that he derived his ideal of the nude body as a symbol of the perfection of the universe and the harmony of natural forms; from Leonardo that he learnt the significance of movement as at once a force of nature and a law of life. But it was within himself he found that impulse to colossalize all he touched which dominates his art.

In a well-known passage Michelangelo set forth his views on the role of plasticity in art. "I say that painting seems to me all the better, the more it tends towards relief,

and relief all the worse the more it tends to the condition of painting." His paintings are the logical outcome of these views. In the *Holy Family* (Uffizi), a tondo painted for Angelo Doni, the sinuous line of the figures is doubtless inspired by Leonardo; yet the rendering of them in illusionist relief, like forms carved in the round, is incompatible with Leonardo's aesthetic. Though the picture deals with a sacred theme, Michelangelo placed two nudes in the background, simply because they satisfied his conception of an harmonious arrangement of the picture surface. Little is known about the *Battle of Cascina* that Michelangelo was commissioned to paint in 1504 on a wall of the great hall of the Municipal Council of Florence, except that he refused to represent a scene of actual fighting. He opted for a group of nude figures in strenuous movement, a pretext for which was furnished by an incident of the battle when the Florentine soldiery was surprised by the enemy in the act of bathing. This work was not carried out and even the preliminary cartoon has disappeared; but we are told that along with Leonardo's *Battle of Anghiari* it constituted, as Vasari puts it, "a lesson for the world." And the scene gave him a welcome opportunity for expressing movement by the tensions of nude forms. Similarly he included nudes in the monument of Julius II (amongst others those wonderful *Slaves* now in the Louvre); in the Sistine ceiling (the *Creation* and the *Drunkenness of Noah*) and, to startling effect, in the *Last Judgment*, where all the figures were naked until the ecclesiastical authorities insisted on having clothes painted on them.

To Michelangelo's thinking, tension and movement were basic to pictorial art, no matter what the subject. This can be seen in his paintings of architectural elements, where the accents are so placed that their presentation has no relation to any system of static weights and thrusts, but is dynamic through and through. And the movement in his painted or sculptured figures is no less forceful; confined within rigorously fixed limits, it is permeated by a sense of terrific strain, an endless struggle to break free. Michelangelo's isolation of the human figure—a sculptural procedure—was diametrically opposed to Leonardo's practice of blending forms into the surrounding atmosphere. In Leonardo's paintings solid objects tend to become atmospheric, whereas in Michelangelo's sky and water harden into stone. Associated with this conception is his rejection of the perspective representation of space. Not that his forms exist *in vacuo*; but the idea of space is conveyed solely by images whose swelling masses presuppose the third dimension. In this respect he cuts the figure of a revolutionary, since one of the 15th-century artists' chief concerns was the rendering of space. Moreover, since space was then regarded as a prerequisite of the delineation of "the real"—indeed as a symbol of the artists' conquest of it—Michelangelo gave the impression of turning his back on reality as well. In any case his cult of the gigantic and his heaven-scaling ambition took the form of a constant, irrepressible urge to transcend reality. This was why he found no satisfaction in the ideal of beauty cherished by the Italians of the Renaissance. Raphael's notion of the beautiful, for example, was based on the art of concealing art, on *sprezzatura*, and could only be realized by an artist at peace with himself, dwelling in an ivory tower. But Michelangelo's ideal was too much bound up

with his moral convictions, too passionate, too closely involved in the tragic history of his times, for his art to have an air of effortless ease and not to reflect his spiritual unrest and the catastrophic changes in the world around him.

This will to discover a form of expression superseding both reality and beauty had its roots in a new attitude to art, the total confidence Michelangelo felt in the style he had worked out and his immense pride and faith in his abilities. Similar traits we have already found in Leonardo and Raphael, but in neither case carried to such lengths.

One of his statues may be regarded as a complete embodiment of his aspirations: his *David*. With this youthful feat he became famous overnight and it is still one of his most popular works. His *David* is a gigantic lad, instinct with energy, poised on the brink of his heroic exploit. We feel that every nerve is on the stretch and the figure of this strapping youth is human power personified. It breathes at once the joyous paganism of Lorenzo's "Garden School," the serene confidence of the Renaissance, its emancipation from medievalism, and the civic pride of the Florentine republic. Yet on its purely artistic merits this statue is inferior to many of Michelangelo's later works.

Basic to the life and art of Michelangelo is an inner conflict, the disquiet of a soul perpetually at odds with itself. True, he sometimes got the better of his divided impulses, but the triumph was short-lived; far from arriving at a definitive solution of his problems, he found them recurring with ever-increasing vehemence. Trained as he had been in Lorenzo's entourage and never weary of declaring his allegiance to the sculpture of antiquity, he was marked out to be a frankly pagan artist—but Michelangelo had an *anima naturaliter christiana*. Moreover he was doubtless greatly exercised by the preaching of Savonarola and that great reformer's prophecies of calamities to come; forebodings that seemed to be confirmed by the advance into Italy of King Charles VIII and his armies. On that occasion he fled to Venice and then to Bologna, where he stayed until the end of 1495.

Michelangelo's successive "escapes" have much to tell us about his strangely complex personality. The first was certainly due to fear. But when in 1506, feeling that Julius II was seeking to humiliate him, he abruptly left Rome, the motive was indignation at such treatment. In 1529, after he had been appointed engineer-in-chief of the fortifications of Florence, foreseeing Malatesta Baglioni's treachery, he fled to Ferrara and thence to Venice; but once the siege had started, he returned to Florence and displayed great courage in the death-struggle that ended in the capitulation of the city. Heroism played an important part in his art and these "flights" may be regarded as sudden breaks in a tension under which his nerves occasionally gave way, though his spirit and morale remained unbroken.

When as a young man he was living in Florence, then by general consent the leading intellectual and cultural center of all Italy, he must have had high hopes for the future. But his rise to fame brought with it new anxieties, intensified when he was called to work at Rome for Julius II, a man as passionate and headstrong as himself, and for Leo X, who had not the faintest inkling of the great artist's spiritual anguish.

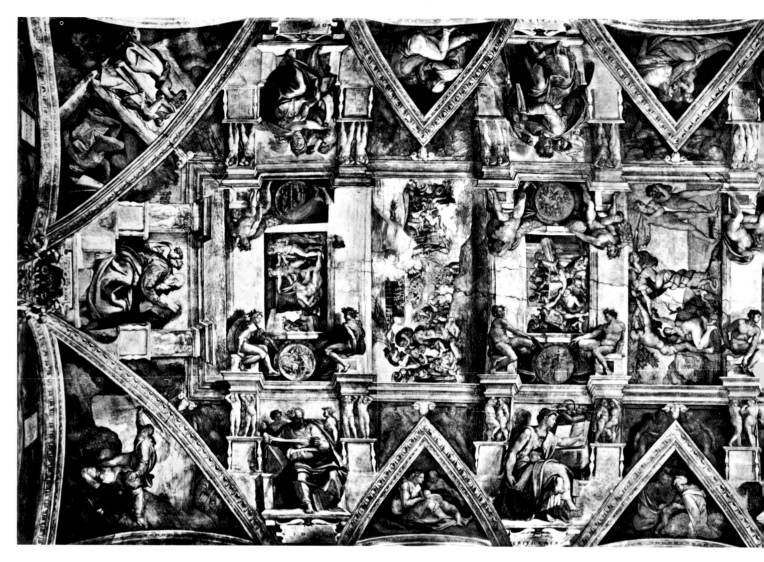

He labored on the Sistine Ceiling, his most "finished" work, without a break from 1508 to 1511, and it is not going too far to say that many Italian artists, Raphael to begin with, and many foreign artists too, regarded it as a heaven-sent revelation. When we enter the huge chapel by the door facing the altar we are immediately conscious of a world of difference between the paintings on the ceiling and those on the side walls. Yet barely thirty years had elapsed since the best painters of Central Italy had made the latter. Their works reveal both the artists' scrupulous deference to Holy Writ and a desire to depict biblical episodes realistically and in spatial settings bringing out the perspective relations of objects in a graceful and convincing manner.

But Michelangelo cared nothing for decoration, for the perspective representation of space, for the chapel whose ceiling he was painting, or for traditional interpretations of the Old Testament stories. He subordinated everything—even the wishes of his patron,

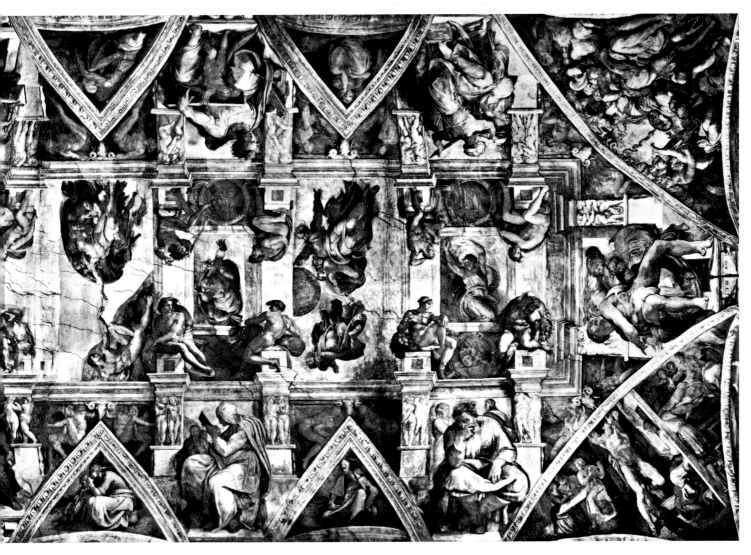

OVER-ALL VIEW OF THE FRESCOS. (CA. 45 FT. × 134 FT.) (PHOTO ANDERSON)

the pope—to his insatiable pride and his determination to create a world exclusively his own, a world in which he mingled superhuman figures with architecture of his own devising and arranged them in an order at once symmetrical and more intricate than that in any previous picture. Such was his mastery of the human form and architectural elements that he now could give free expression to his genius, conjuring up a world quite other than the world we know; in no wise mystical, but supremely grandiose, built to an heroic scale. It is sublime in the way that a frenzied uprush of natural forces, a cataclysm can be sublime. Yet this sublimity was, rather, inherent in the mind of Michelangelo, who stamped with his personality every figure, every detail. The biblical allusions are no more than adjuncts to the painter's vision of a grandeur never seen on earth. The Sistine ceiling is of the nature of an epic poem, but its epic quality derives not from the story that is told but from the artist's supercharged imagination.

After the Sistine ceiling Michelangelo's life became still more agitated and arduous, despite the vast success of these paintings. Thanks to Raphael's intervention the Pope allowed him to leave Rome. Between 1513 and 1516 he made the *Slaves* for the colossal tomb that Julius intended to have erected for himself; also the *Moses*. After being given a commission for the façade of San Lorenzo he wasted much time collecting the necessary marbles in the quarries, only to find on his return that the project had been abandoned as being too costly. Next he agreed to execute the Medici tombs in the sacristy. Meanwhile there had been the sack of Rome (1527), the restoration of the Florentine republic (1527), and the siege and fall of Florence (1530). Michelangelo, whom Pope Clement VII had taken back into favor, was compelled to work for the very men who had been his enemies of yesterday. Within the seventeen years between the death of Julius II in 1513 and the collapse of the Republic in 1530 fell the most critical phase of Michelangelo's life and art. For Italy, too, these were tragic years, involving as they did the loss of the country's independence, in whose defense Michelangelo had played a valiant part. Then there had come the cleavage between the Catholic Church and Luther's party of Reform. Though the Reformation was suppressed in Italy, the movement, spreading over Europe, fired the enthusiasm of many of the greatest Italian thinkers, amongst them Michelangelo, rebellious as ever. He had a deep affection for Vittoria Colonna, whose spiritual father Bernardino Ochino was, by way of Giulia Gonzaga, in touch with the Spanish reform-minded religious writer Juan de Valdes. But in the event neither Vittoria Colonna nor Michelangelo dared go as far as heresy and with the coming of the Counter-Reformation both acquiesced in it. All the same they were in sympathy with the views of the Italian reformers, views somewhat different from those prevailing in other countries where the Reformation had gained ground. Going back to Savonarola, the Italians declared that Man and God were, spiritually, in direct communion with each other. But they also had a humanist background, which led them to differentiate moral conduct from mystic fervor. The result was that when Calvin sought to organize Protestantism on political lines, he encountered the hostility of the Italian heretics who had taken refuge in Switzerland. For though they had rejected the dogmas of the Roman Catholic Church, they had no wish to adhere to any other form of dogma.

It is easy to imagine Michelangelo's spiritual anguish, compelled as he was to serve the Counter-Reformation whose aims were at variance both with his own mystical faith and with that spirit of the Renaissance which had meant all to him in his youth and his distress found poignant expression in his poems of this period.

Comparisons have been often, perhaps too often, made with Dante. But the Sistine ceiling does not depict a journey to Hell or to Paradise. Between Dante and Michelangelo humanism had intervened, and what the latter depicted was, rather, a journey into the past, to the origins of the human race. Michelangelo's conception of this journey was strictly ordered; the architectural elements which form its framework underlie the images, acting like the pedestal of some gigantic monument, and it is this that gives the ensemble an atmosphere of repose, even a somewhat abstract quality.

The *Prophets* and *Sibyls* are in a class apart. Michelangelo's original intention had been to paint in the center only some architectural elements shored up laterally by figures of apostles seated on thrones, and even in the final version the *Prophets* and *Sibyls* uphold the central panels in which are the historical scenes and the *ignudi*. As a result of this Caryatid-like function they are given proportions that seem gigantic relatively to those of the other figures. All are leaning forward from their thrones; some of them—Zachariah, Joel, Isaiah, the Delphic, Erythrean, Persian and Libyan Sibyls—are so placed that they seem like architectural units. On the other hand, Ezekiel is making a gesture of surprise and Daniel's head, thanks to an opportune patch of shadow, seems to jut forward outside the framework of the picture, while a bold foreshortening separates Jonah from the architectural context.

MICHELANGELO (1475-1564). ESTHER AND AHASUERUS, 1508-1511.
FRESCO, CEILING OF THE SISTINE CHAPEL, VATICAN.

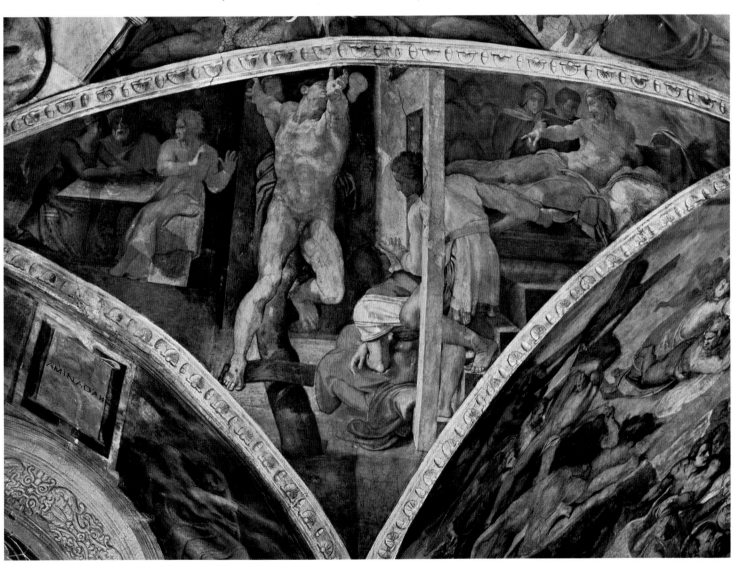

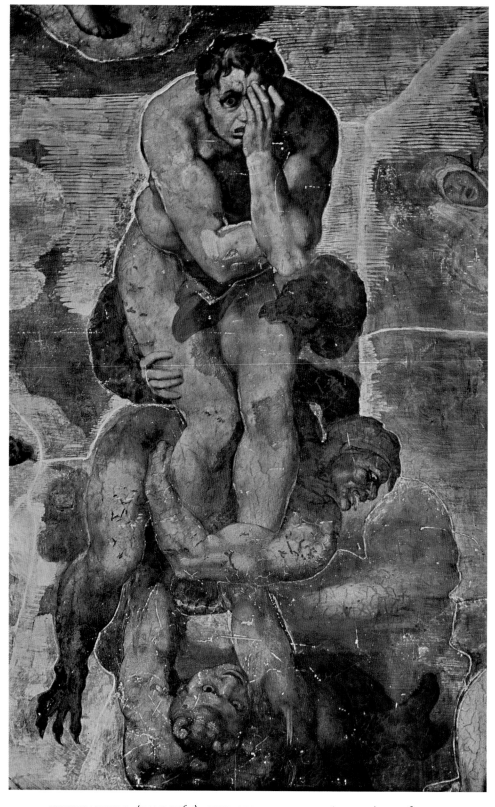

MICHELANGELO (1475-1564). THE LAST JUDGMENT (DETAIL), 1536-1541.
FRESCO, SISTINE CHAPEL, VATICAN.

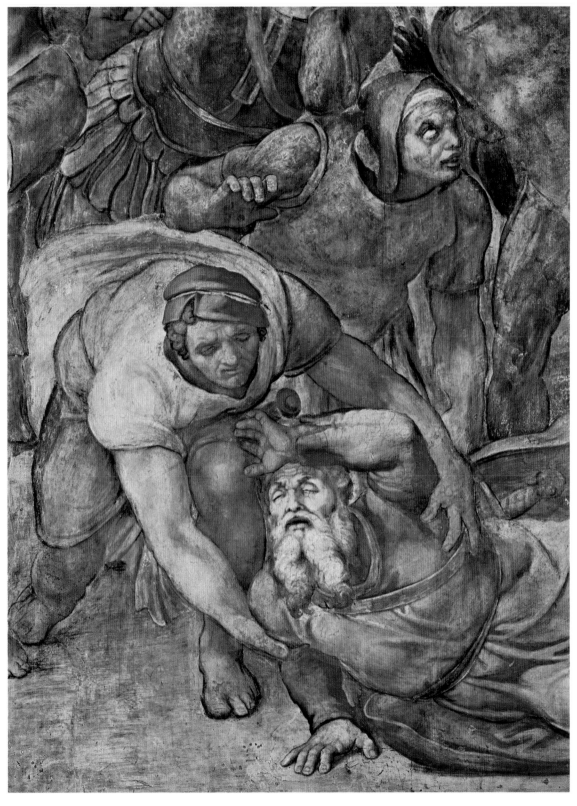

MICHELANGELO (1475-1564). THE CONVERSION OF ST PAUL (DETAIL), 1542-1545.
FRESCO, CAPPELLA PAOLINA, VATICAN.

To link up the *Prophets* and *Sibyls* with the central zone Michelangelo had to invent a plastic motif corresponding to the projections of the thrones. This is the function assigned to the *ignudi*. Like that of the nudes in the background of the *Holy Family*, their only *raison d'être* is one of illustrating Michelangelo's cherished ideal of the perfection of the nude human body. But they also play a leading part in the pictorial architecture of the whole and Vasari may well have had them in mind when he observed that "Michelangelo was more successful in subordinating the lay-out to the figures than the figures to the lay-out."

The first historical scene Michelangelo painted on the ceiling was the *Deluge*. Here he had not yet settled down into his style; there are frankly realistic elements in the landscape and indications of planes echeloned in depth. Some of the figures, for example the mother and two children on the mountain top and others of the same group, are admirable, but the general effect is unsatisfactory. Michelangelo could conjure up filled but not empty spaces and, above all, he had not the knack of "representation." None the less we owe to him some of the most stupendous plastic creations the world has ever seen, those which made contemporaries speak of the *terribilità* of his art. The plane he worked on was not that of illustration, but an ideal plane of pure forms. Thus while eschewing empty spaces, he had also to avoid the counter-risk of over-crowded compositions. *Noah's Sacrifice* is not one of his most successful works. First of his masterpieces (taken in their chronological order) are the *Temptation* and the *Expulsion of Adam and Eve from Paradise*. The tree which overhangs both scenes, at once dividing them and binding them together in a single decorative rhythm, is a skillfully devised structural element, while the figures have a rare grace, even a touch of femininity seldom found in Michelangelo's work, though it is also present in the *Creation of Eve*. In depicting Eve's sensual beauty, her panic fear when driven from Eden and her poignant invocation of the Father she has offended, Michelangelo reveals the depth and warmth of his human feeling. Most famous of the scenes on the Sistine ceiling is the *Creation of Adam*. Despite the angelic host surrounding God the Father, the two leading figures seem alone. The rising ground behind Adam and the flowing drapery behind his Creator build up zones of darkness stressing the modeling of the figures. The overwhelming tension we sense in them might have been "discharged" in close proximity, but by a brilliant stroke of the creative imagination Michelangelo has limited their contact to the touch of finger on finger. By this rhythmic approach of the two fingers, giving and receiving life, these mighty forms are imbued with a supremely poetic quality, the spiritual significance of the scene takes precedence of its material side, and the fully plastic volumes acquire a purely ideal import. In the *Creation of the Animals*, *God creating the Luminaries*, and the *Division of Light and Darkness*, we have almost an impression that the huge form of God the Father hovering in the upper air is laboring against the pull of gravity; but there is superb power and grandeur in the gesture of the Creator of the Sun, Moon and Stars. In the scene that is a pendant to this, the *Creation of the Plants*, the Creator's muscular body, shown in back view and in strong foreshortening, with willfully exaggerated stresses, brings

out the essentially decorative function of Michelangelo's figures. Thus the *Creation of Adam* remains the high point of Michelangelo's art prior to 1511. But the paintings in the lunettes are rich in intimations of the future; sculpturesque effects are subordinated to a wholly pictorial beauty, and we find a variety of colors conspicuously absent in the rest of the ceiling, which seen from a distance seems almost monochrome. Here the elongation of forms foreshadows mannerism, figures melt into the atmosphere and are here and there accented with dramatic *élans* (in the case of Jehovah, for example). All of which suggests that Michelangelo was moving towards "true" painting, even towards Baroque—but this tendency was cut short by his return to sculpture.

In this connection we may recall an observation made not long ago by Clements on the relationship between the art of Michelangelo and the notion of *sprezzatura* formulated by Castiglione and put into practice by Raphael. Unlike the latter Michelangelo had no desire to paint his figures with apparent ease; on the contrary, he wished them to demonstrate that much hard work and mental effort had gone to their making. Disdaining natural facility, he even went out of his way to pile up difficulties, so as to enjoy triumphing over them in the end.

When from the ceiling painted between 1508 and 1511 we turn to the *Last Judgment*, painted between 1536 and 1541 on the wall behind the altar in the Sistine Chapel, we cannot fail to be struck by the many differences between the two works. Here there is no architectural framework binding the scene together; Michelangelo seems to have deliberately discarded everything in the nature of a setting so as to concentrate on the human figure, which under such conditions could enjoy greater freedom of movement and be presented with the maximum dramatic force. Instead of architecture there is an empty expanse of blue-black sky: space without depth or infinite according to the painter's wish. All the figures except that of Christ are arranged in groups articulated in relation to the empty space surrounding them. From the horizontal ledge on which Christ stands, stream down two long clusters of bodies: the Blessed moving towards God and the Wicked hurtling down to hell. These two streams of humanity are linked together by the angels of the Last Judgment.

We must remember that this fresco has reached us in very poor condition and that all the figures, originally nudes, were repainted by the order of Pope Paul IV, between 1555 and 1559, after the Inquisition had accused Michelangelo of leanings towards Lutheranism. So when we seek to understand the part played by the figures in the general effect the artist was aiming at, we have to picture to ourselves how they originally appeared. For by so strongly centralizing and compressing the dramatic elements Michelangelo stepped up the emotive tension of the ensemble; there is none of that sense of relative calm implicit in the figures of the ceiling, due there to the structural lay-out which precluded any extreme displays of feeling. But in the *Last Judgment* he calls on individual gestures to evoke a frenzy of despair. The expressive power of this amazing scene does not derive from an arrangement of pictorial masses; on the contrary, we see an array of separate forms moving like painted statues within the composition. Each gesture expresses the torment of the Damned; this is the end of

the world, not Resurrection Day; Christ does not judge but execrates, while the terror-stricken Virgin crouches at His side. This is an apocalypse of universal anguish rather than a Last Judgment. God is pouring the vials of His wrath on all alike and Michelangelo himself, like a fallen Titan rejoicing in the world's catastrophe as a compensation for his own predicament, seems to join forces with this God of vengeance.

In his frescos in the Cappella Paolina, the *Conversion of St Paul* and the *Crucifixion of St Peter*, painted between 1542 and 1550, there is none of this titanic passion. Here all is resignation, even at times indifference. True, the gestures in the *Crucifixion of St Peter* are diversified and balanced in *contrapposto*, but they are, after all, irrelevant. The only stylistic innovation is the use of colors more varied and lustrous than before. Thus towards the close of his career he came to discern the possibilities of Venetian art and what he might have learnt from it.

We can follow the changes coming over his style in the series of superb drawings made for the *Crucifixion*; in them he uses *sfumato* as if he were painting in colors, softening outlines and creating delicate transitions. Here it is almost as if he were talking to himself, expressing his love and compassion for suffering humanity. Michelangelo's insistence on plastic values, his arrogance and paganism, his passionate cult of the grandiose have yielded to the tranquillity of a soul already touched by divine grace. These drawings foreshadow the *Rondanini Pietà* whose sublime immateriality and rejection of plasticity reflect the mood of melancholy acceptance of the human lot that had now descended on this once rebellious soul. Thus in his old age Michelangelo paid heavily for the pride and Promethean fervor of his youth, for the heroic part he played in the great adventure of the Renaissance. But it was for this very reason, the disillusionment that came to him towards the close of his career, that he broke with the Renaissance and became the first modern artist.

Michelangelo's statues are a visual transcription of his changing moods. After the *David* (1501-1504) embodying the pride of youth rejoicing in its strength, he made about eleven years later the *Slaves*, victims of circumstance whose life force has not been extinguished by suffering and bondage. The rebellious young *Slave* in the Louvre might be an avatar of Prometheus Bound. The allegorical figures of the Medici tomb demonstrate the soul's release from its earthly prison. Like the rivers of Hades, *Dawn* and *Twilight, Night* and *Day* symbolize man's unescapable destiny, while, beyond the pale of this earthbound life, the image of the Madonna watches over the mortal remains of Giuliano and Lorenzo de' Medici. The allegorical motif derives, apparently, from Plato's *Phaedo*, while the statues were inspired by works of classical antiquity, if at a far remove. The movement vitalizing the nude figures, a tendency to expand forms and that elongation of proportions, with a view to stressing poses which makes the figures so grandly dominate their architectural setting, reveal the artist's dissatisfaction with his earlier achievements. What we have here is not a struggle against rigorously fixed outlines, but a step towards an art set wholly free from linear contours—a tendency that finds its climax in the Madonna, a frozen effigy of grief, yet given a form so sinuous that there is no longer any question of clearly defined circumscribing lines.

MICHELANGELO (1475-1564). THE RONDANINI PIETÀ, 1555-1564. SCULPTURE.
(HEIGHT: 6 FT. 1½ INCHES) CASTELLO SFORZESCO, MILAN.

The major works of sculpture of the final period are a series of Pietàs. In the last of these, the *Rondanini Pietà*, we see all that Michelangelo had now eliminated in his own art and all that he bequeathed to the art of the future. From the *David* to this last *Pietà* he followed a path leading away from the physical to the spiritual, from appearances to the secret workings of the heart, from paganism to Christianity, from representation to expression. And we have a feeling that all the calamities that had befallen Italy were synthesized in this *Pietà*, whose very formlessness is a paradigm, as it were, of that elusive entity, the human soul.

CORREGGIO The small town of Correggio, from which the painter Antonio Allegri (ca. 1489-1534) took the name by which he is always known, lies in the fertile, climatically favored plain of Emilia. At that time it was under the sway of the Da Correggio family who had had their hour of glory in the 13th and 14th centuries, but by now were little more than country squires who, under unrelenting pressure from the Pope, the Emperor and the great houses of Este and Gonzaga, were hard put to it to retain some semblance of their former power and prestige. During the artist's lifetime the castellan of Correggio was Veronica Gambara (1485-1550), a lady of much intelligence and a poetess highly esteemed by Aretino, Ariosto, Francis I and the Emperor Charles V. However, Correggio never actually worked for the ruling family, though he kept in touch with them and Veronica Gambara made no secret of her admiration for one of his pictures, a *Magdalen*.

Thus like Raphael Correggio came of provincial extraction, but the court of his hometown was far less important and less culturally developed than that of Urbino. No one ever thought of sending the young artist to Rome or Florence; indeed it is doubtful if he ever visited either of these cities. He worked for the churches of the towns of Correggio and Reggio and other places in the neighborhood, but it was in Parma that he created the works which placed him in the front rank of the artists of the day. In 1510 Reggio had been wrested from the Este family, lords of Ferrara, by the Pope, and the same fate befell Parma, which was incorporated in the States of the Church from 1512 to 1531. This being so, Correggio could not benefit by commissions from the Este court, whose protégés, in any case, were Giovanni and Battista Dossi. And it was only relatively late in Correggio's career that Federigo Gonzaga of Mantua became alive to his exceptional gifts and commissioned him to paint a series of mythological scenes depicting the Loves of Jupiter, for presentation to the Emperor Charles V.

Despite the remarkable qualities of these frankly pagan pictures, we must not forget that Correggio spent most of his life painting for convents and provincial churches pictures and frescos with a popular appeal, and that it was to these alone that he owed a worldwide renown that lasted for the next three centuries.

Correggio was shaped by the best artists of the region where he lived. In his youthful works we find echoes of the art of Francesco Bianchi Ferrari (said to have been his

CORREGGIO (CA. 1489-1534). THE ASCENSION (DETAIL), 1520-1524.
FRESCO, CHURCH OF SAN GIOVANNI EVANGELISTA, PARMA. ▶

70

teacher), Lorenzo Costa and Francesco Francia who familiarized him with the glowing colors of 15th-century Ferrarese painting. From the days of Vasari to the present time all writers on Correggio's art have dwelt on the superb quality of his color and there can be no question of the importance of these early contacts with Ferrarese tradition. Nevertheless a young, forward-looking artist can hardly have failed to find Ferrarese draftsmanship outmoded and it is not surprising that Correggio decided to go to Mantua to study Mantegna, then regarded as the best humanist painter of all North Italy and famed for the vigor of his drawing, his knowledge of anatomy and scientific perspective.

All the same the style of his maturity clearly owed more to Leonardo than to the Ferrarese or to Mantegna. Even in the earliest works we can see that his creative imagination led him to aim at effects of light and shade akin to Leonardo's *sfumato*, though treated in a quite personal manner. Did Correggio meet Leonardo and did he have an opportunity of seeing his pictures in Milan and Florence? Though it is still impossible to answer these questions, we need only look at his paintings to see that none understood better than he the lesson of the master, and none so greatly profited by it. For what Correggio took over from Leonardo was not only his *sfumato* but also his feeling for compositional unity, directness of expression, and rapidity of movement —thereby effecting the transition from the 15th to the 16th century.

There is an interesting parallel between the early phases of Correggio's career and Raphael's. Both moved away from provincialism towards the art of the capital, from Quattrocento to Cinquecento style, under Leonardo's guidance. But, after that, their paths diverged since, though starting out from the innovations of Raphael, and above all Michelangelo's, Correggio developed a sweep and a new breadth of treatment in his handling of figures so personal that in his later phase we are hardly conscious of any debt to previous masters. Perhaps the most that can be said is that Correggio's art brings to mind a free interpretation of the color and light of the Sistine ceiling, without the formal and moral rigor or the dramatic complexity of Michelangelo's imagery. Also, while responsive to Raphael's aesthetic harmony and transcendent beauty, he was at a loss when it came to integrating them into his art. For there is no denying that he lacked the noble spirituality of Michelangelo and Raphael; this perhaps is one of the reasons why it has always seemed so difficult to account for the indisputable excellence and attractiveness of his work.

If Correggio's contemporaries praised him to the skies, they often found his work "surprising." Shocked by his technical audacities, one of them went so far as to describe the groups in the dome of Parma Cathedral as "a hash of frogs"! Vasari, a discerning critic, though biased in favor of the mannerism initiated by Michelangelo, was clearly baffled by him. "No one," he writes, "excels him in the handling of colors," and he goes on to extol the sweetness, the *morbidezza* and grace of Correggio's art, his elegant renderings of women's hair, the smiling charm of his angels, the beauty of his landscapes. But he points out and even stresses shortcomings in his drawing, due, he suggests, to the fact that Correggio had the misfortune to be out of touch with Rome and knew nothing of Michelangelo and the art of antiquity.

Thanks, however, to the Carracci's vigorous championship of his work and the high value then attached to their opinion, Correggio's position was unassailable throughout the 17th century. And when the spiritual ferment of that century gave place to the bland, lighthearted skepticism of the 18th, Correggio became the most adulated of all painters—so much so that, writing in 1760, Daniel Webb remarked that he had "put his critics to the blush," and he was hailed, not without reason, as a precursor and a master of rococo.

But time took its revenge in the 19th century, when Correggio was berated by several eminent authorities, amongst them Kluger, Burckhardt and Ruskin. He was accused of wanton sensuality, of failing to achieve "absolute form" and architecturally ordered composition. But against these quite unjustified strictures we may set off the views of the more clear-sighted critics who drew attention to the very real charm of his artistic personality: his humanistic Epicureanism, his touches of whimsy, the suavity of his forms and his gift for expressing the subtlest shades of feeling. Better perhaps than any other writer Riegl has shown a true appreciation of his art when he sees in it a symbol of modern taste reacting against the past, and in the painter a precursor of Baroque. For ancient art depicted *will* that isolates the individual, whereas Correggio depicts *feeling*, which brings him into harmony with his environment and becomes *desire*, which in its turn gives rise to *ecstasy* (religious or erotic).

Correggio painted some small religious pictures before 1514, the year in which he was given the order for a large altarpiece, the *Madonna and St Francis* (Dresden), for the Franciscan church at Correggio. Best of the small pictures is the *Nativity* (Brera, Milan). Here glowing Ferrarese color and clean-cut drawing in the Mantegna manner are merged into a soft penumbra glimmering with the first rays of daybreak, while forms are rendered with an extreme lightness of touch, as though not to ruffle the silence enveloping the Child. In the far distance the sky is beginning to brighten. This subordination of the figures to an over-all play of light and shade certainly derives from Leonardo, but in Correggio's case it does not serve any "scientific" purpose. What, on the contrary, he is aiming at is the expression of quite homely feelings, too spontaneous to be sentimental, too everyday to be religious. Nor do the angels fluttering in the air, an alcove reminiscent of a Roman edifice and a pillar serve to give this placidly domestic scene the air of a sublime event. Perhaps it was because he wished to transpose the sacred narrative on to the level of a folktale that Correggio linked together—for the first time, as Emile Mâle has pointed out—the "Nativity" and the "Adoration of the Magi," a juxtaposition of popular iconographic themes often resorted to by later painters. In the *Madonna and St Francis*, one can feel that this was the artist's first venture into the field of large-scale composition; the parts tend to break away from the whole, to the detriment of the over-all unity of the scene. Some traits of 15th-century art persist, but there is a keener feeling for the monumental and for movement, and space is more freely rendered. This is very different from Mantegna's representations of the Madonna and Saints, and there is no trace of his architectonic order in the lay-out. Nor do we find as yet the well-knit unity of expression that Correggio

CORREGGIO (CA. 1489-1534).
MADONNA WITH THE MAGDALEN AND ST JEROME,
CA. 1527-1528. (80½ × 55½") PINACOTECA, PARMA.

was later to attain. But the Virgin and Child are wonderfully graceful figures, while the throbbing colors have a new intensity.

Some years later Correggio decorated the Camera di San Paolo (the Abbess's room) in the Convent of St Paul at Parma. In it he depicted a sort of pergola hung with garlands, a motif taken from Leonardo's decorations in the Sala delle Asse of the Castello Sforzesco in Milan, but treated here more fancifully, with small oval windows through which cupids are peeping. These tiny figures play much the same part as Michelangelo's *ignudi*. But unlike the latter, they are mere whimsies, though such is their verve and playful grace that we forget they serve no functional purpose. Similarly the trellis of the pergola is upheld by shell-shaped lunettes containing allegorical fantasies. Their subjects are culled from mythology, but interpreted so freely as to seem mere *jeux d'esprit*. Some female nudes, draperies and tracts of exquisitely suave color are other engaging features of this mythological extravaganza.

Above the fireplace is a picture of Diana paying homage to the chastity of the Abbess —clearly, if humanism was in favor at the Convent of St Paul, it was not taken overseriously but romantically, not to say light-heartedly, and it was in this spirit that Correggio chose to interpret it.

The cupola fresco in the Benedictine church of San Giovanni at Parma, made between 1520 and 1524, shows a distinct advance. The style is broader, even monumental, though without any diminution of the liveliness and gaiety distinctive of Correggio's art. Here he realized his conception of the *beau idéal*, a conception less exalted than Raphael's owing to his undisguised delight in sensual appeal. The figure of James the Less may be regarded as one of the first embodiments of this ideal. In a small lunette painted in foreshortening he portrayed St John the Evangelist in Patmos; owing to the position and dimensions of the lunette the figure seems to be lunging forward out of its architectural setting and the driving force behind this movement produces a strange impression of spiritual power. Illusionism, perhaps, but illusionism

of a kind that justifies itself triumphantly. It is certain that the Cinquecento painters had no trouble in painting certain objects with a verisimilitude that deceived the eye—a case in point is the painted tapestry in the Vatican which visitors regularly took for real tapestry—but Correggio employed no purely material *trompe-l'œil* devices of this kind. Though his religious feelings went no deeper than a superficial, unthinking acquiescence in the Christian verities and legendry, these feelings were sufficiently active and vital to hoodwink beholders into thinking that the bodies he so lovingly painted in his religious scenes were endowed with lofty spiritual significance. The subject treated in the cupola of San Giovanni is the *Ascension*. A highly skillful foreshortening of Christ's body brings out the infinite blue void above the clouds, while the glorious nature of the event, the triumph of their Master, is reflected in the happy faces of the apostles young and old. There are few figures and each is strongly individualized. Here, too,

Correggio has solved the problem of giving the illusion of boundless space solely by his handling of figures, but it must be admitted that he lacks Mantegna's constructive sense, as revealed in the Bridal Chamber of the Ducal Palace at Mantua.

So much admired was the *Ascension*, both for its novelty and its beauty, that the Chapter of Parma Cathedral invited the artist to paint the dome of the Cathedral. The subject set was the *Assumption of the Virgin*, and the work took him four years (1526-1530). The dome being much larger, the painter realized that he could better convey the impression of infinite space by refraining from defining the plastic qualities of individual bodies and by merging figures into a swirling throng levitated in a vast ascending movement. This movement is suggested by different zones of light super-imposed one upon the other up to the open sky, and seconded by color gradations. Correggio subordinated the human figure to pictorial construction in terms of light, starting out from the apostles nearest to the earth, pouring up through the clouds and glancing across the angels and the soaring

CORREGGIO (CA. 1489-1534). ANTIOPE, CA. 1531. (74¾ × 38¾″) LOUVRE, PARIS.

CORREGGIO (CA. 1489-1534). MADONNA WITH THE MAGDALEN AND ST JEROME (DETAIL), CA. 1527-1528. PINACOTECA, PARMA.

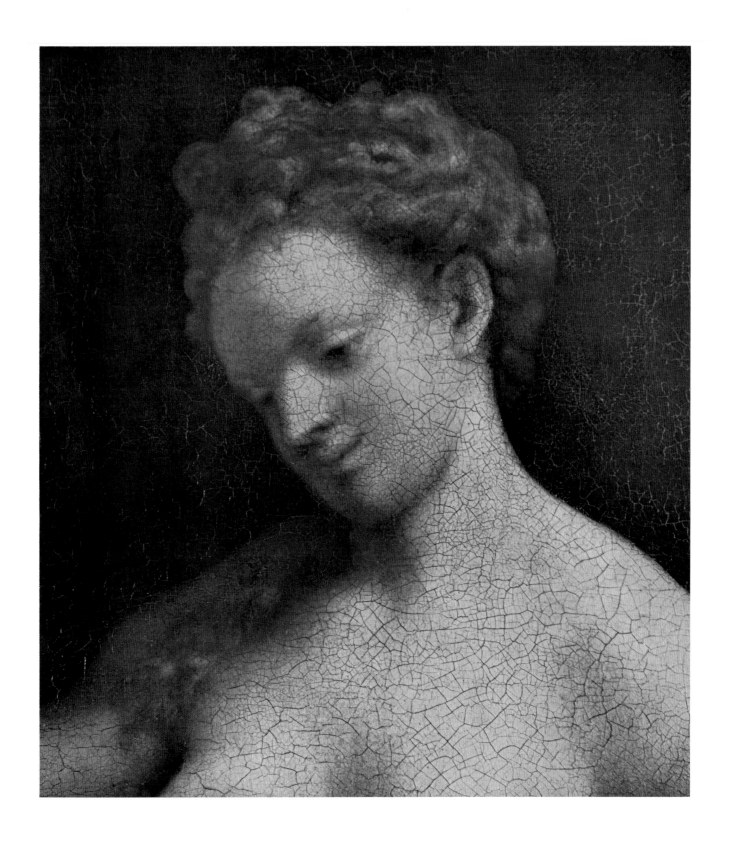

CORREGGIO (CA. 1489-1534). DANAË (DETAIL), CA. 1531.
GALLERIA BORGHESE, ROME.

figure of the Virgin, towards the Light supreme of Godhead. Here he gave expression to an ecclesiastical ideal and this may explain why the Parma dome was adopted as the model of all Baroque decoration.

The early *Nativity* and the dome of Parma Cathedral represent the two extremes of Correggio's approach to religious art; the former is like a simple melody, the latter like the finale of a symphony scored for full orchestra. Between these limits are several Madonnas, all grace and suavity: the *Campori Madonna* (Modena), the *Madonna of the Basket* (National Gallery, London), the *Virgin and Child* (Uffizi), and the *Mystical Marriage of St Catherine* (Louvre). One of the best altarpieces is the *Madonna with the Magdalen and St Jerome* (Parma) where the transversal composition links up the figures as in a *sacra conversazione*. The Magdalen's gesture as she bends her cheek towards the Child is a delightful touch, poetic and tinged with sensuous appeal. The *Madonna della Scodella* (Parma) and *Night* (Dresden) are charming interpretations of sacred scenes treated in a pleasantly homely way. But Correggio was less successful in altarpieces whose themes lent themselves to decoration only; in such cases—in, for example, the *Madonna and St Sebastian* and the *Madonna and St George* (Dresden)—all seems artificial and contrived. Nor was he capable of representing a dramatic scene, as is quite plain in the *Deposition*. In it he drew inspiration from some earlier work, perhaps a Gothic prototype, that seemed to offer possibilities for a "modern" re-interpretation; unfortunately his attempt to combine the physical signs of mental anguish with the gracious charm that is the keynote of his art led to untoward results, a sort of parody of grief.

Federigo Gonzaga, or his mother Isabella d'Este, was happily inspired when he or she gave Correggio an order for a series of pictures on mythological themes. *Antiope* (Louvre), *Danaë* (Rome), *Leda* (Berlin) and *Io* (Vienna) are perfect of their kind; in them the artist had themes exactly suited to his temperament. In Parma Cathedral he achieved an ecstatic vision sublime in its own right and not as a religious revelation. The same is true of *Io. Danaë* and *Leda* are pagan through and through, yet there is something more, something not due exclusively to lovely colors and enchanting landscapes. In no scene of antiquity do we find this special grace, a recall or an echo as it were of the divine grace latent in this fine artist's soul. Thus even the frankly pagan pictures have a Christian undertone. In *Io* the milky white of the nude blends into the cooler grey of the clouds, while a smoothly flowing arabesque and highlights on the body give the composition an harmonious unity. In *Danaë* the whiteness of the body, welling up from a dark background, seems gradually to overflow the picture surface, giving the figure the soft translucence of an ivory bas-relief. In *Leda* the tale of Leda and the swan is presented as a holiday outing in the country, organized by some attractive maidens. Delightfully natural, it illustrates one of the lighter sides of Renaissance life.

For three centuries art lovers admired and enjoyed the paintings in the Parma dome. Meanwhile, however, the picture sequence of the *Loves of Jupiter*, secluded from the public eye in palaces, seems to have been ignored, one of the reasons being the alleged "impropriety" of these enchanting scenes—scenes in which, for once, Correggio felt free to indulge, without constraint or qualms of conscience, his natural instincts.

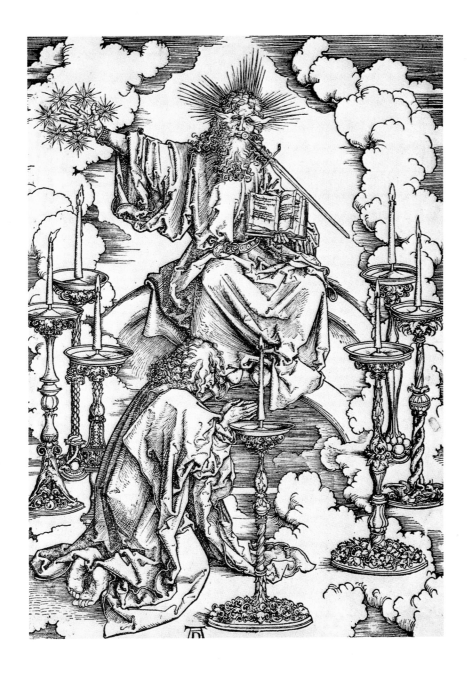

THE RENAISSANCE IN GERMANY

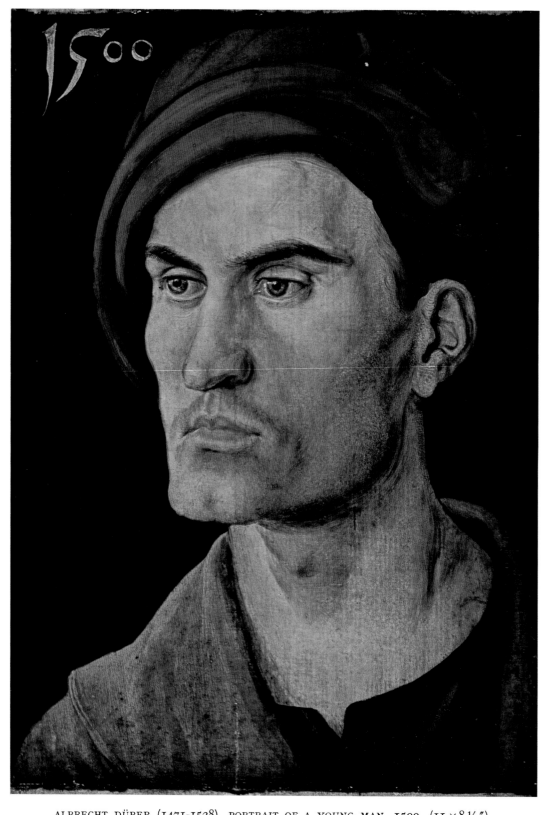

ALBRECHT DÜRER (1471-1528). PORTRAIT OF A YOUNG MAN, 1500. (11 × 8¼″)
ALTE PINAKOTHEK, MUNICH.

2

FROM DÜRER TO HOLBEIN

B Y the time Leonardo, Raphael and Michelangelo had embarked on their careers, they had behind them a full century of humanism; and not only had the works of classical antiquity come under careful observation, but (what was even more important) a mathematical theory of art practice had been drawn up. By an intensive study of what then were called "measurements" (i.e. geometry and perspective), the humanists had placed art on a scientific basis, and stressed the superiority of the mental equipment essential to the artist as against the mere craftsman or artisan.

In the preface to his book published in Nuremberg in 1525 and entitled *Under-weysung der Messung* (Instruction in Measurement), Albrecht Dürer wrote: "Until now many gifted young painters have been shaped in Germany without any theory of art and guided solely by the light of daily experience. They have sprouted up like wild plants, untouched by the gardener's hand. Though some by constant practice have acquired facility and produced works that, if arbitrary and irrational, possess a certain power, all understanding painters have deplored their blindness. It is clear that with their deftness of hand and great experience in handling color our German painters have developed remarkable proficiency, but they lack the science of measurements." This, according to Dürer, had been discovered by the Italians, in the light of the art of antiquity, two centuries before; in point of fact, Brunelleschi had worked out the laws of pictorial perspective about a century before Dürer wrote these words.

But, needless to say, there is far more to art than "measurements." Grünewald, who knew nothing of them, was a superb painter and if Dürer achieved greatness, this was not because he had studied geometry and perspective at Bologna (relatively late in life, as it so happened). Despite his enthusiasm for the discoveries of the Italian Renaissance, Dürer still belonged temperamentally to the Middle Ages, to which even more conspicuously Grünewald also belonged. Indeed it has recently been suggested that the latter deliberately reverted to the idealistic art of an earlier age; an hypothesis perhaps uncalled for, since in the Low Countries, where under the lead of Van Eyck and his disciples a great art had developed at the beginning of the 15th century, life still went to a medieval rhythm for the next hundred years and more.

In any case there was so prodigious a flowering of art in Germany during the early 16th century that this country vied with Italy for supremacy in Europe. A great religious revival had taken place a century earlier and, with it, despite political dissensions,

had come a new, if ill-defined, awareness of man's moral and intellectual possibilities. Whereas in the 14th there had been few German universities, many were founded in the following century—at Leipzig, Greifswald, Freiburg, Ingolstadt, Tübingen and elsewhere—and some of these displayed a lively interest in the humanistic conceptions that were making good in Italy. Nevertheless the German people was still at the mercy of provincial overlords and the Empire still too weak to protect its liberties. Thus, from the end of the 15th century on, there were frequent revolts against the authority of the local princes, while the harshness of ecclesiastical taxation fomented religious unrest. The result was that when in 1517 Martin Luther nailed his famous Theses to the door of the Castle Church at Wittenberg, while the élite saw in this no more than an incident in some sectarian dispute, the populace at large knew better, as did the shopkeepers and artisans.

When we study the artistic climate of Germany during this period, we find that, after the definitive establishment of Lutheranism in several parts of the country, aesthetic activity soon declined. But there were good reasons why, in the years when Luther was in active conflict with the Empire and the Papal See, German art rose to heights it had never previously attained.

From the viewpoint of the modern historian and in time's perspective, Luther's protestantism is seen to be no more than a return to the theological conceptions of the Middle Ages; there was little really new in his doctrines. But the German artists did not trouble their heads with theology. It was Luther's driving force, his popular appeal, his revolt against the malpractices and highhandedness of the civil and ecclesiastical powers that fired the enthusiasm of both populace and artists. None the less, once protestantism had crystallized into a system of dogmas, bigoted for all their novelty, the artists' inspiration seemed to dry up at the source.

During the 14th century mysticism had swept over Germany, especially in the days of Johann Eckhart (ca. 1260-1327) whose writings were condemned by the authorities because they advocated direct communion with God, independently of the Church. All the same Eckhart exercised considerable influence not only on heretical sects but also on orthodox believers, while by way of that profound thinker Nicholas of Cusa (1401-1464) humanist culture gave a philosophical turn to the mystical aspirations of the age. Nicholas held that God can be apprehended by intuition, an exalted state of the intellect in which all earthly limitations cease to function. He extolled the "simpleton," that is to say the unschooled layman who does not read or write but, like the first fathers of the race, studies the works of nature, God's book, with an understanding eye. Thus he heralded the transition from medieval mysticism to modern empiricism, and he is known to have influenced Leonardo's thought.

We find a similar attitude in Albrecht Dürer and this explains both his predilection for the imagery of medieval tradition and his feverish quest, in drawing after drawing, of an ever fuller understanding of the natural world. His leanings towards mysticism and his strong moral sense led him to approve of Luther. In 1520 he wrote: "If some day God vouchsafes me to meet Doctor Martin Luther, I shall make his portrait from

the life with the utmost care and engrave it on copper, so as to perpetuate the memory of the Christian man who did so much to deliver me from a great affliction of the soul." And when a report went round that Luther had been imprisoned, Dürer, not knowing that this rumor was a feint, voiced his grief with passionate sincerity. "O God in heaven, have mercy on us; Lord Jesus, pray for thy people and succor us in our hour of need. I beg you, all good Christians, to join with me in pitying this man inspired by God and praying Him to send us another man enlightened as he was. O Erasmus of Rotterdam... mark how the foul tyranny of worldly might and the powers of darkness prevail in the land. Listen, O Knight of Christ, take horse and ride at our Lord's side, defend the truth and win the martyr's crown." It may seem strange that Dürer should couple Erasmus and Luther in this way, but this confusion of ideas reflects the state of mind of many Germans at the time. They resented the authority of the Church of Rome because it was something alien and incomprehensible, and also because of a conviction —not altogether unfounded—that it was corrupt. But what they wanted was a reform of the Church, not open war with it, and highly as they thought of Luther, his intransigence dismayed them. Hence the popularity of the great humanist Philip Melanchthon (1497-1560) who, while alive to the moral justifications of Luther's crusade, hoped to effect a compromise with the Catholic Church on the basis of humanism—which of course meant nothing to Luther. To Melanchthon's thinking, as Panofsky has pointed out, Dürer's style bore the marks of the *genus grande* (of the art of Rhetoric), Grünewald's of the *genus mediocre*, and Cranach's of the *genus humile*. This classification obviously derives from Aristotle's *Poetics* in which poets and painters are divided into three categories according as they "imitate" men superior to ourselves, inferior to ourselves or similar to ourselves.

Today, no doubt, many see in Grünewald a far greater artist than Dürer. But, as a good humanist, Melanchthon regarded as the "grand manner" that which approximated most closely to the classical; and this, as was only to be expected, he discerned in the art of Dürer, who sought to interpret even the protestant revolution in terms of humanism. But every revolution ends by going to extremes, and when, to safeguard protestantism, Luther allied himself with the temporal powers, the Anabaptists stirred up the nation to revolt. They advocated a way of life in strict accordance with the Gospels, a sort of Utopian communism, and total submission to that inner voice which kept the individual in constant touch with God. Such was the origin of the Peasants' War in South Germany.

In 1526 Dürer completed the *Four Apostles*, which he dedicated to the Town Council of Nuremberg, his native town. On these panels he inscribed extracts from the Gospels and a brief homily bearing on the political and religious crisis of the day. "In these perilous times it behoves all civil authorities to be mindful of their duty of withstanding human temptations and hearkening to the voice of God alone. God forbids that anything should be added to or substracted from His Word." This was a warning against the Anabaptists. For though Dürer was ready to give the religious revival his moral support, he refused to follow the zealots when it came to destroying humanist culture.

With Grünewald it was quite otherwise. After the Anabaptists had been expelled from Seligenstadt where he lived, he was deprived of his office of Court Painter—which suggests that he had been involved with the extremists. He now took refuge with the protestant community at Halle, then at daggers drawn with the archbishopric, and it was there he died in 1528, the same year as Dürer. In the inventory of his estate mention is made of a "seditious document," which was in fact a declaration in favor of certain citizens accused of fraternizing with the rebels. And the difference between the attitudes of Grünewald and Dürer towards the Reformation throws light on the part played by humanism in Germany.

GRÜNEWALD

The artist's first biographer, Joachim von Sandrart, writing in 1675, describes him as "Matthaeus Grünewald, commonly known as Matthaeus von Aschaffenburg." While stressing the painter's vast renown, he admitted that, to his regret, only the scantiest information about him was available. Since then, however, documents have been unearthed showing that his real name was Mathis Neithardt-Gothardt. The name "Grünewald" never appears, but in view of its general acceptance, it has always been retained. Sandrart seems equally unreliable as regards the birthplace he assigns to Grünewald. Probably he was born at Würzburg somewhere between 1455 and 1460. According to some authorities his earliest extant work is the portrait of a young man, to all appearance an art student, engaged in drawing; this bears the monogram M N, suggesting that it may be a self-portrait. However, its ascription to Grünewald is hazardous. In 1485 Mathis Neithardt was living in the Bishop's Palace at Aschaffenburg (this shows that he was older than Dürer), where he had Canon Heinrich Reitzmann for his friend and patron. In 1490 he left Aschaffenburg and went to work as a sculptor at Worms. In 1501 he was enrolled as a citizen and master artist at Seligenstadt near Aschaffenburg, where in 1510 he supervised the rebuilding of the castle, his official designation being "Master of Works and Painter in Ordinary to the Prince Elector" (Archbishop Uriel von Gemmingen). Before this he had painted, about 1503, the *Christ Scorned* at Munich and, about 1505, the Basel *Crucifixion*. Records show that a son, Andreas, was born to him in 1512. About this time he was commissioned by Guido Guersi, Superior of the Antonian convent church at Isenheim, to paint the polyptych at present in the Musée d'Unterlinden at Colmar. Begun about 1512, this gigantic work was completed three years later. Meanwhile Grünewald also worked at Seligenstadt where (according to Reitzmann) he was in 1514 and again in 1516. A year later and again in 1519 he was employed as Superintendent of Works at Aschaffenburg, and in 1520 he entered the service of Archbishop Albrecht of Mainz who had formed a humanist center there. In that year he attended the coronation of Charles V at Aachen, where he met Dürer.

Led by Goetz von Berlichingen (immortalized by Goethe in his play of the same name) the peasants occupied Aschaffenburg and Seligenstadt, but in 1525 Albrecht of Mainz expelled them. His recovery of power was followed by savage reprisals and Grünewald had to leave. He moved to Frankfort in 1526 and found employment there

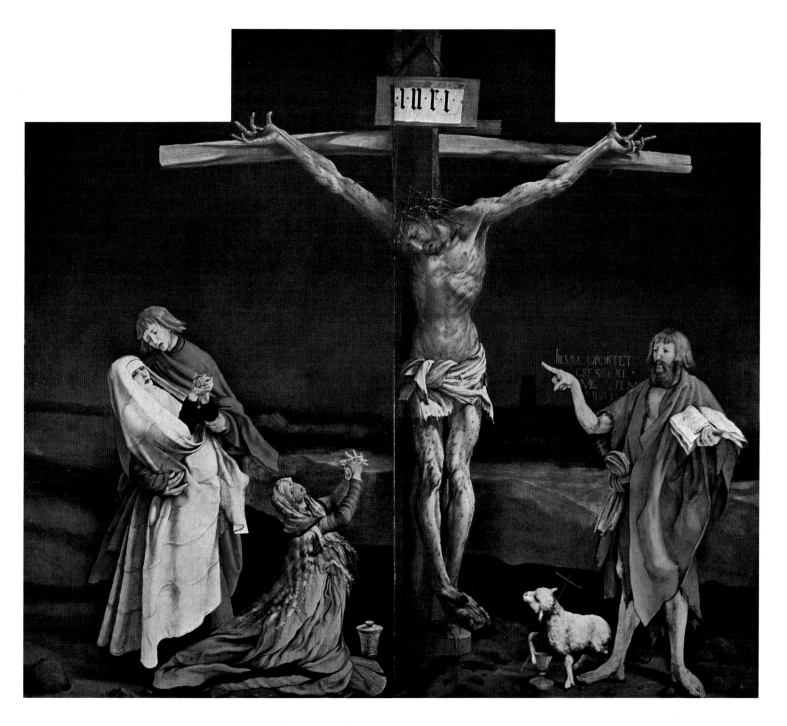

MATTHIAS GRÜNEWALD (BEFORE 1460-1528). CRUCIFIXION, 1512-1515. (105¾ × 120¾")
CENTRAL PANEL OF THE ISENHEIM ALTARPIECE. MUSÉE D'UNTERLINDEN, COLMAR.

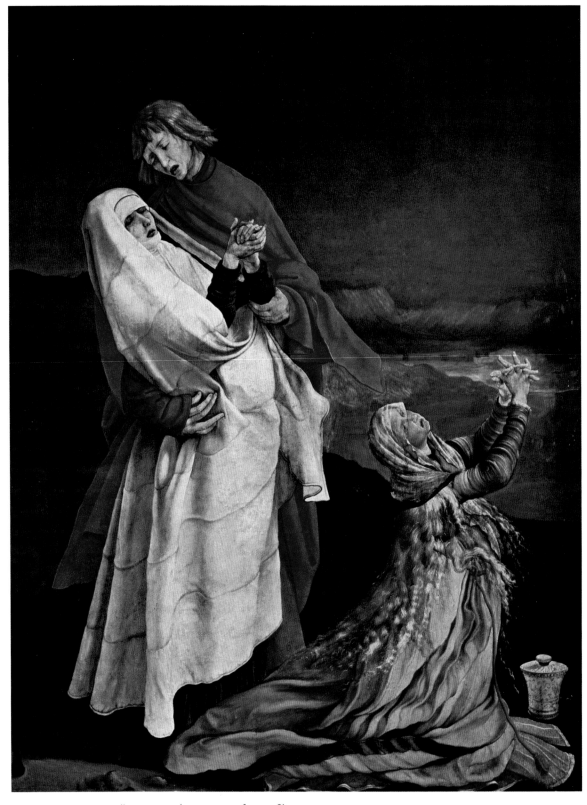

MATTHIAS GRÜNEWALD (BEFORE 1460-1528). CRUCIFIXION, DETAIL: ST JOHN THE EVANGELIST, THE VIRGIN AND MARY MAGDALEN, 1512-1515. ISENHEIM ALTARPIECE. MUSÉE D'UNTERLINDEN, COLMAR.

as an hydraulic engineer; next year, perhaps because he felt unsafe in the atmosphere of persecution then prevailing in that city, he moved to Halle where he had trusted friends. He died in 1528.

This outline of the facts of Grünewald's life, brief and perhaps over-simplified though it is, illustrates one of the facets of his curious personality. Much esteemed as a fine craftsman, as an hydraulic engineer and as one of the leading German painters, he nevertheless failed, or declined, to win a high place in the social order of the day, the reason being his intense religious zeal and his devotion to his divine Master. To his mind, the revolting peasants were the true successors of the ancient martyrs—and such a view was bound to tell against his worldly success. He died a poor man, leaving to his heirs only a few "banned" books and his paint brushes.

The origin of his mystical preoccupations has been traced to the "Revelations" of the 14th-century saint, Bridget of Sweden, whose works had a great vogue in Germany

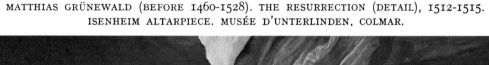

MATTHIAS GRÜNEWALD (BEFORE 1460-1528). THE RESURRECTION (DETAIL), 1512-1515.
ISENHEIM ALTARPIECE. MUSÉE D'UNTERLINDEN, COLMAR.

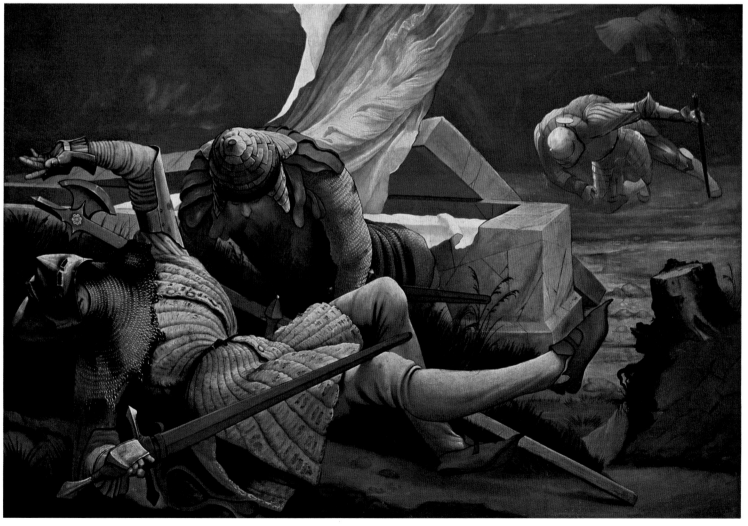

at the beginning of the 16th century. Her poetic images have sometimes an expressive power approximating them to Grünewald's creations. St Bridget's invocation of Christ on the Cross is a case in point. "The hair and beard were steeped in the blood flowing from the wounds inflicted on the Sacred Head. The bones, hands and feet of the most precious Body were cruelly cleft asunder. So brutally wast Thou scourged and scored with agonizing wounds that Thy innocent flesh and skin were torn and lacerated till the agony was past enduring. Thus didst Thou suffer for us, O Man of Sorrows!"

And no less impassioned is her invocation of the Virgin: "Thy brows and eyelids excel in splendor the sun's rays... Let the beauty of thy thrice-holy cheeks be lauded more than the roseate effulgence of the dawn. Praised be the sacred mouth and soft lips fairer than the beauty of roses and all flowers. Let thy sacred arms and hands and fingers be blessed and revered eternally, more than the costliest gems... Let thy most precious breast be lauded more than the purest gold; when the hammer strokes echoed in thy bosom and thy heart was wrung as though clenched in a vice, how cruel was thy agony!"

Such is the realism, such the instancy of her visions, that the saint does not scruple to dwell on all the parts of the body with a view to glorifying their several functions and redemptive virtues. And so as to transcend the material and attain a realm of spiritual values, she never specifies the *form* of what she is describing, but pictures it in terms of color and radiant light. To ascend from the world of matter to the celestial plane—that was the Swedish mystic's aspiration, and Grünewald's too.

So preponderant is the part played by the Isenheim Altarpiece (1512-1515) in Grünewald's œuvre that we have thought it best to devote our attention chiefly to this masterwork of 16th-century art. It is divided into three independent parts. (1) *The Crucifixion*, flanked by *St Anthony* and *St Sebastian*, with *The Entombment* on the predella. (2) *The Virgin adored by Angels*, flanked by *The Annunciation* and *The Resurrection*. (3) *The Apotheosis of St Anthony* (sculpture) with *The Hermits Anthony and Paul in Converse* and *The Temptation of St Anthony* on the side-panels.

One of the first things that strike us in this altarpiece as a whole is the artist's obvious disregard for architectonic lay-out and uniformity in the representation of the various scenes. In the first part, for instance, though the two saints on the lateral panels are depicted symmetrically and each is posted on a marble pedestal, one is placed higher than the other and only one of the wings has a landscape background. In the second group there is a still greater discrepancy, the rendering of space in the *Annunciation* being entirely different from that in the *Resurrection* where the scene is depicted wholly on the surface—or, what comes to much the same thing, in undefined or infinite depth. In the *Virgin adored by Angels*, the central picture of the second triad, no visual relationship exists between the figure of the Virgin on the one hand and the group of angels and the building on the other.

The images, then, do not compose a "represented" scene; rather, they are "presented" independently. This lack of visual unification and ordered structure brings the time factor into prominence. For Grünewald gave little thought to that spatial

unity which, created by the Florentines in the early 15th century, conditioned all Italian art. True, Grünewald was not ignorant of linear perspective, but we have only to look at the *Annunciation* to realize that his way of seeing was still essentially Gothic, though associated, in his case, with humanism. For the figures are by no means Gothic; they have the immediacy, the forcibleness, the anatomical expressionism, the factual reality characteristic of Renaissance art; and, in particular, its light effects.

Thus there is a disharmony between the general conception of this altarpiece and the painter's handling of its diverse elements. Yet so powerful is Grünewald's creative genius that he turns what might have proved a handicap or blemish into a constructive factor and to deplore the lack of co-ordination would be idle pedantry. The *raison d'être* of this unorthodox composition is the state of high emotional pressure at which Grünewald worked; he put himself, heart and soul, into every figure he portrayed with an intensity unparalleled in the history of art.

Bürger has rightly pointed out that in Grünewald's painting bodies *per se* play a secondary role; gestures count for more. This is also true of Gothic painting and sculpture, but though here the expressive quality of gestures is no less intense than in the work of the great Gothic artists, bodies are far more in evidence. In other words the conflicting claims of the spiritual and the material are reconciled in a continuous dramatic tension implicit in the artist's style, not an extraneous factor deriving from the subject, and that "cosmic" smile we glimpse now and again in the *Virgin adored by Angels* signifies for Grünewald something no less poignant than the grief of the mourners over the dead Christ.

The dramatic tension mentioned above is particularly apparent in the drawings. In a study for *Peter the Apostle* (Dresden), Peter sinks to the ground praying for mercy, dazed by an unseen light—unseen because it shines within the soul alone. In the *Kneeling Virgin* (Berlin) where, probably owing to the apparition of the archangel bringing the glad tidings, the Virgin has abruptly stopped reading, the figure seems to have no body; all we see is a complex of sinuous lines purporting to render hair and garments but actually expressing Mary's awed amaze. And in the *St Dorothy* (Berlin), a study for the lost altarpiece of Mainz Cathedral, the linear rhythms giving movement to the figure build up an effulgence so intense as to translate it into the "world of light" glimpsed by the mystics of all ages.

Again, in the Isenheim *Crucifixion*, it is the figures alone that hold our gaze and we hardly notice the landscape dwindling into darkness like a vision of infinite space from which emerge the figures, grandiose presences suddenly materialized out of the ambient air. Christ's body is heavy and, though nailed to the Cross, seems to be sagging earthwards. His flesh a mass of hideous wounds. As against this macabre scene, the Magdalen cuts an almost childish figure with her hair streaming over her pink dress, as she invokes the dead Savior. No bigger than a little girl's, her stature is out of scale with that of the other figures, and the color of the dress is almost gay, yet proportions and colors alike combine to give the maximum emotional intensity to her cry of lamentation. Still more impressive are the juxtaposed figures of the Virgin and St John.

The Virgin's white dress billows out unconfined by contour-lines, and contrasting with the Evangelist's red robe, this patch of white shines forth, fluid, impalpable, almost weightless. Here we have a visual "effect" defying analysis but singularly impressive.

In the *Virgin adored by Angels*, the Virgin is the focal point of a whole cataract of wonderfully luminous colors. The angels are singing and the light, too, sings. The colors do not harmonize with the light and this is as it should be; a concord would bring peace, and here everything is rushing heavenward, straining towards an ecstasy transcending earthly joy. Grünewald has given loving care to the decoration of the chapel; he has included an (unaccountable) crowned saint in the scene and even inserted a bed, a vase—and a bucket! Perhaps these touches of homely realism were meant to counterbalance the almost overpowering joy of the celestial hosts.

The *Annunciation* is the most "rational" panel of the altarpiece. Here colors and light harmonize, space is well defined, the figures behave in a reasonable way—and by the same token Grünewald's peculiar charm is missing. But in the *Resurrection* he once more let his teeming imagination have its way. At the bottom of the picture sleeping soldiers sprawl, bathed in an unearthly light, while vividly colored draperies stream up above the tomb, following and covering the body of the ascending Lord. In *The Hermits Anthony and Paul in Converse* the figures of the saints are beautifully done; Anthony radiant with light and joy, full of vitality, and Paul the Hermit old, decrepit, his bony fingers withered by long privations. The landscape is all in jagged spikes, a scene of ghoul-haunted desolation like that which shows St Anthony assailed by a horde of hideous monsters, so grotesque as to be unconvincing.

But this indifference to plausibility was Grünewald's way; as early as 1503 or thereabouts in the *Christ Scorned* (Munich), he had shown that the spiritual significance of his subject was his chief concern. Here the cruelty depicted is on the moral rather than the physical plane. Though there are traces of inexperience in this picture, his style has already taken form. Nearly two decades later, in the Munich *Sts Maurice and Erasmus* (1520-1522), we find a new feeling for the monumental, while the wealth of colors and brilliant highlights create the atmosphere of a scene in some old legend. Here Grünewald gave free rein to his amazing virtuosity in his rendering of the light reflected on Saint Maurice's armor, while no less striking is his portrayal of the brown, negroid face. And in the harrowing *Crucifixion* (Washington), the face of the Evangelist is truly unforgettable.

In the church of Stuppach near Mergentheim (Württemberg) is a *Virgin* dated 1519, in every way worthy of the *Virgin* of the Isenheim Altarpiece. She is smiling and a rainbow replaces the conventional aureole. It was St Bridget who had put into the Virgin's mouth the words: "Prayers hover above the world like the rainbow in the clouds," and as Benesch has pointed out, this many-colored radiance linking up the Virgin with the sky is an emblem of the union of the earthly paradise and heaven.

These pictures may perhaps be described as "commentaries" on Grünewald's supreme achievement, the Isenheim Altarpiece. They go to prove that his power lay above all in that sense of a world beyond reality which enabled him to spiritualize all he touched and to imbue even a smiling sky with strangely dramatic tension.

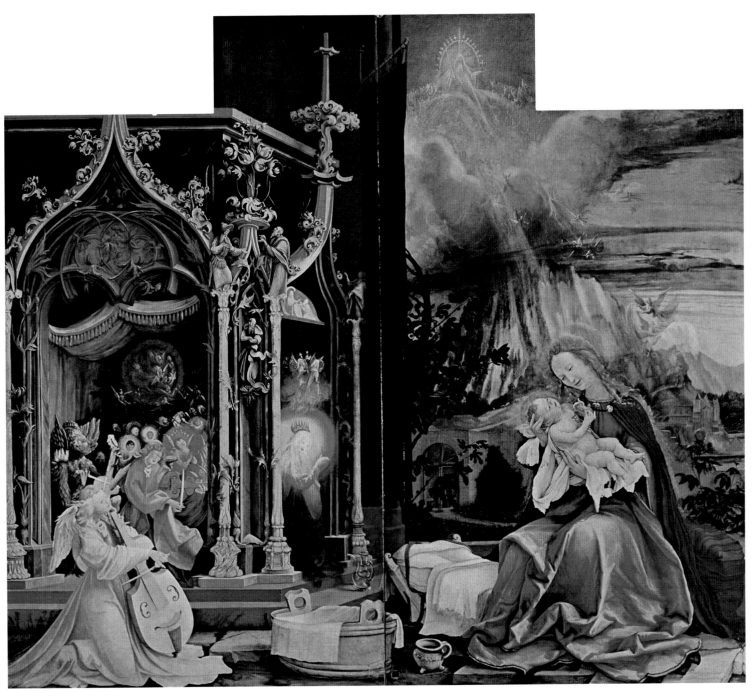

MATTHIAS GRÜNEWALD (BEFORE 1460-1528). THE VIRGIN ADORED BY ANGELS, 1512-1515.
(105 ¾ × 120 ¾″) ISENHEIM ALTARPIECE. MUSÉE D'UNTERLINDEN, COLMAR.

Albrecht Dürer was born at Nuremberg in 1471. Son of a goldsmith, he began by following his father's profession; next, he studied painting under Michael Wolgemut, from 1486 to 1490. At the end of his apprenticeship he started on the usual *Wanderjahre* of the German student. His original plan was to go to Colmar to complete his studies under Martin Schongauer, but he spent a year and a half traveling about Germany (where exactly is not known) and when early in 1492 he reached his destination, it was to learn that the Colmar master had died shortly before. After making a name for himself as a wood-engraver at Basel, then a leading center for the publication of books illustrated with woodcuts, he moved to Strasbourg. In 1494 he went back to Nuremberg and soon after his return got married. The marriage was not a success, as his wife, who was both strait-laced and parsimonious, objected to her husband's devoting so much time to mathematics and humanistic studies (his closest friend was the local humanist Willibald Pirckheimer) instead of attending to his "trade." Their difference of opinion illustrates in a homely way the contrast between the medieval tradition of the artisan and Dürer's determination, by dint of sheer hard work, to attain the status of a Renaissance artist.

Soon after his marriage he went to Venice where he stayed until the spring of 1495, visiting meanwhile other North Italian cities. A remark made by him at this time shows how much store he set on Italian art and how keen was his desire to participate in the Renaissance movement: "In the last century and a half the Italians have uncovered and exploited what had been hidden for a thousand years." He went to Venice a second time in 1505, staying there until 1507. By then he was no longer the unknown painter of his first sojourn but acclaimed as a great master. The German community in Venice gave him a commission for an altarpiece; he was made much of by the nobility and struck up a friendship with Giovanni Bellini whom of all the Venetian painters he most admired. Dürer spent some time in other towns, and at Bologna he gave careful study to the Italian methods of rendering perspective and proportions.

When in Nuremberg, between these two stays in Italy, he devoted all his time and energy to engraving. On his return from his second journey he studied foreign languages as well as mathematics, preparatory to the writing of his big treatise on the theory of art (published in 1525). In 1512 he was given commissions for various kinds of work by the Emperor Maximilian who until his death (in 1519) continued to patronize him. Between 1520 and 1521 Dürer made his last long journey, this time to Aachen, its object being to secure from the new Emperor, Charles V, a continuance of his pension. He was handsomely received and his request was granted. After his return to Nuremberg, his health began to fail, and he died in 1528.

It was thanks to Dürer that first the tastes and then the theories of the Italians became acclimatized in the German-speaking lands and it was he who familiarized his fellow countrymen with the new conception of art as a means to knowledge. For aside from his creative impulse, Dürer had an insatiable interest in natural phenomena of all kinds, in scientific and religious problems, and he was the first and perhaps the only German who was something of a "universal genius" of the type exemplified by Leonardo.

Though Dürer's art is essentially Germanic, Vasari was convinced of his Flemish origin, the reason being that he could not bring himself to believe that any great nordic painters existed outside Flanders. "If," he wrote, "this singular and universal artist had been a native of Tuscany instead of Flanders and could he have studied as we have the treasures of Rome, he would have excelled us all, as he is now the finest and most esteemed of all the Flemings."

We have already spoken of Dürer's feelings about Luther, and it should here be pointed out that it was thanks to the climate of the early Reformation that the artist was able to voice his most profound convictions. Believing as he did in an "illumination from within," his aspiration to an absolute was a necessary consequence of his religious faith. Yet this conflicted with a no less imperative will to the expression of form, linking up with the desire for an objective understanding of reality that was the result of his Italian sojourn. Hence that inner conflict which persisted throughout his career and which accounts for his hostility to the real, his intolerance of those canons of "measurement" or proportion to which nevertheless he had vowed allegiance. Sometimes, in his most successful works, he succeeded in reconciling these anomalies. But these favored moments were sporadic; usually he was dissatisfied with his productions, and his temperamental restlessness, his eagerness to explore all that differed from himself and his environment led him to strike out continually in new directions. As already mentioned, there was a strain of the fantastic in his make-up, and though what won him Europe-wide fame in his own time was the technical perfection of his means, it is his indefatigable spirit of enquiry that makes him seem so near to us today.

Doubtless one of the reasons why Dürer wrote his treatises was a desire to clarify his views on art, but we must not forget that such yearnings for an absolute and a taste for pedagogy are innate in the German temperament. His *Underweysung der Messung* (Instruction in Measurement) is dated 1525, his "Treatise on the Fortifications of Cities, Towns and Castles" was published in 1527 and his "Treatise on Human Proportions" (posthumously) a year later. When he made his second journey to Venice, Dürer, like other northern painters, was already acquainted with the rules of perspective. But none of the northerners had as yet any notion of what Dürer himself styled *Kunst*, art *qua* art, as distinct from questions of technique. The novelty of this conception, sponsored by the Italians, lay in the fact that it was more concerned with painting itself than with the observation of nature. It stood for the *perspectiva artificialis* as against *perspectiva naturalis*, while enjoining what was called the "correct construction" of all three-dimensional objects, including the human body. Thus, for him, the theory of proportions depended on that of perspective also. When Dürer returned from his second stay in Italy he had learnt at Bologna the methods of "correct construction"; his instructor, whoever he was, was obviously someone familiar with Piero della Francesca's writings and his purely geometric analysis of painting. Dürer restated the Italian theories, merely adding some technical demonstrations. And he agreed with the Renaissance Italians in regarding perspective as not only a means of representing actual space but also as an ideal norm of order and harmonious design.

In his engraving *Adam and Eve* he set out to demonstrate his mastery of the classical conception of beauty, but as time went on, and under Leonardo's influence, he came to realize that beauty assumes many forms and that proportions change in accordance with the structure and movements of the figures represented. Moreover, as a result of studying Leonardo's so-called caricatures, he went into the question of the total or partial distortion of bodies, with a view to showing (as a warning to painters) how easy it is to lapse into the monstrous.

Dürer's own aesthetic is set forth in Book III of his *Human Proportions*. Though some of the ideas derive from Italian writers on art theory, he does not share their views regarding the nature of "pure beauty" and goes so far as to attack those who think that beauty can be achieved by measure and proportion alone. Pursuing his researches on a deeper level, he investigates the "mystery of Nature" from the angle of the artist, coming to the conclusion that a work of art can be truly great even though the subjects

ALBRECHT DÜRER (1471-1528). SELF-PORTRAIT, 1493. (22 ¼ × 17 ½")
LOUVRE, PARIS.

ALBRECHT DÜRER (1471-1528). ALPINE LANDSCAPE, CA. 1495. (8 ¼ × 12 ¼")
WATERCOLOR DRAWING. ASHMOLEAN MUSEUM, OXFORD.

depicted be of a mean or uncouth kind. And in any case the artist was constrained to make do with relative beauty since absolute beauty was perforce an unattainable ideal.

What Dürer aimed at above all was a coherency between the parts and the whole, an appropriate, all-embracing symmetry and harmony. Geometric rules-of-thumb cannot tell us what we should select in the appearances of nature; that is a matter for the artist's intuition and his sense of pictorial construction. "No man can create a beautiful picture merely by the exercise of his imagination unless he has a mind equipped by the observation of reality. That is why a great painter need not wholly copy nature; he can exteriorize what he has stored up within himself for years, his accumulated visual experience." Thus an inner synthesis is effected enabling the artist to body forth the real and the imaginary at one and the same time. This theory was quite a new one, unknown to the Italian Renaissance, which was already moving towards the conception of art as pure creation.

Dürer's conception of the artist's vocation is set forth in another passage. "Only great artists will be able to understand the strange view I now put forward, out of deference to the truth. In one day a man may sketch something with his pen on a sheet of paper or limn it with his graver on a little block of wood, and what he thus devises in a single day may be far better and more artistic than a big work over which he has toiled assiduously for a whole year. This is a heaven-sent gift. God often bestows the possibility of discovery and the intuition of making something excellent on a man whom none other equals in his age and the like of whom has not been seen before and will not be seen again for many, many years." This view of the artist is one that appeals to the modern mind, despite the efforts of a certain school of criticism to question the existence of great art geniuses endowed with "a heaven-sent gift."

In the lands north of the Alps there had developed during the 15th century a tendency to break with Gothic tradition and to devote more attention to the faithful representation of reality and improvements in technique. Following Jan van Eyck, the northern painters made use of breaks in the line, more and more frequent, and graduated colors in relation to the ebb and flow of light. At that time line bulked large in the art speech of the day (notably in that of Rogier van der Weyden) and Dürer too, who had been trained as a goldsmith before he took to painting, proved his extreme interest in design by his lifelong activity as an engraver on wood and copper. Indeed, when we remember that he was first and foremost an engraver, we cannot but be amazed at the driving force of that creative instinct which enabled him triumphantly to cross the frontier from the purely linear to the pictorial, and after being an alumnus of Medievalism to become a great Renaissance master.

From Martin Schongauer Dürer learnt the virtues of precision, a strictly ordered interpretation of visual data controlled by a well-marked style. As against this, an anonymous painter, the so-called Housebook Master of Amsterdam, showed him that touches of improvisation did not come amiss and that by a dexterous handling of light, line could be reduced to a minimum. However, his early training was that of an illustrator and it was to his virtuosity as a draftsman in the medieval tradition that, in his lifetime, he owed his vast prestige. But in order to achieve an art in which form *qua* form was paramount he inclined towards a classical style enabling him to range beyond mere illustration, which, calling for meticulous craftsmanship and extreme attention to details, however trivial, involved all too often a sacrifice of the general effect.

If Dürer showed so much interest in those "specialities" of his Italian contemporaries, perspective, proportions and the nude, this was because he wished to find a means of integrating the human body into its spatial environment. He copied—or freely interpreted—one of Mantegna's prints, another by an anonymous Ferrarese painter, and Pollaiuolo's *Battle of Nudes*. During and after his visits to Venice and North Italy he turned to good account his studies of the work of Gentile and Giovanni Bellini, Leonardo and several other Italian masters. Jacopo de' Barbari's art revealed to him the perfection of classical form and the virtues of *contrapposto*. He was also interested in the works of classical antiquity, though he may have become acquainted

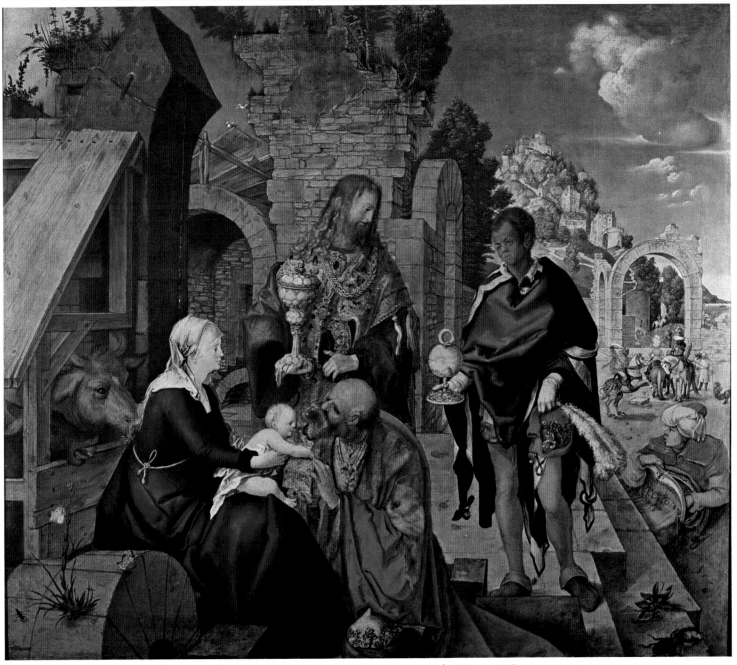

ALBRECHT DÜRER (1471-1528). THE ADORATION OF THE MAGI, 1504. (39¼ × 44⅞″) UFFIZI, FLORENCE.

with them only through Italian drawings. These explorations of a realm of art so foreign to that of late medieval Germany led him away from the time-hallowed religious themes towards secular subjects.

Always inclined to go to extremes, he was in a sense the most aggressive of all the painters of his time. But he was a many-sided man, so vain of his good looks as to portray himself as a new "Nazarene" (Munich, 1500), intensely serious, yet capable on occasion of displaying a sprightly wit, even in his homilies.

When crossing the Brenner Pass in 1495 he made three watercolor sketches of Trento and the environs; delightfully spontaneous works, painted as personal *souvenirs de voyage*, not for others' eyes. Here there is no lingering over details, these pictures are completely natural, not to say unstudied, and the touch has an airy lightness—they are in fact "impressions," lively, colorful and charming to the eye.

His first large-scale work was the *Apocalypse* series of fifteen woodcuts, completed in 1498, which created something of a sensation and enjoyed immediate success. In these the real and the impossible are so closely intermixed that it is difficult to distinguish between them. In the *Vision of the Seven Candlesticks* St John the Evangelist is shown kneeling not as a mere spectator but as a participant in the scene. The candelabra are in finely wrought gold and though the scene is set in the clouds, so realistic is it that we forget the fantastic nature of the vision. When the subject is more dramatic this transposition on to the plane of the real is even more complete. The woodcut of the *Four Horsemen of the Apocalypse*, for example, is a scene of violence, charged with terror and strewn with bodies of the dead and dying; but for the presence of a few symbolic accessories it might be the picture of a medieval battle. In *St John devouring the Book*, the angel who according to the Revelation had "feet as pillars of fire" is given a head encircled with rays and instead of legs two little columns ending in flames. Dürer takes such pains to make the unreal realistic that we forget this is the stuff of dreams. Yet, though some details in these woodcuts are perfect of their kind, we cannot help feeling that the artist overstressed the horrific elements in the sacred text. The same might be said about the earlier series of seven woodcuts known as the *Large Passion*. Several German and foreign painters drew inspiration from these woodcuts, notably from the *Ecce Homo, Bearing of the Cross* and *Lamentation of Christ*.

Between 1495 and 1500 Dürer's output was prodigious. For one thing, he now started engraving on copper, better suited than wood for the realistic rendering of details. But we can see that he was aiming at a style more flexible than that of Schongauer, whose engravings were miracles of exactitude. At this time Dürer's vision approximated more nearly to that of a painter, and it was the period of some of his most successful prints. *St Eustace and the Stag* (1501) has the quality of a folk tale and in it figures and animals are set out in depth as well as in the foreground, without any logical links between them. And it is due to this "irrational" arrangement that the forms, though rendered wholly in the Renaissance manner, do not clash with the fairytale atmosphere of the little scene. In *Nemesis* (1501-1502), inspired by a Latin poem by Politian, Dürer demonstrates his entire mastery of the proportions of the female nude standing and shown in profile. Still we cannot help feeling that he tends to overemphasize realistic details such as the woman's bulging muscles and obesity and that the powerful effect of this figure is due chiefly to its finely balanced poise. The *Temptation* (1504) demonstrates his skill in bringing out the tactile values of different substances with his graving tool. The two nude figures have a classical beauty and thanks to a well-devised *contrapposto*, in pursuance of which the weight of each body bears on one limb only, the scene, though static, is charged with potential movement.

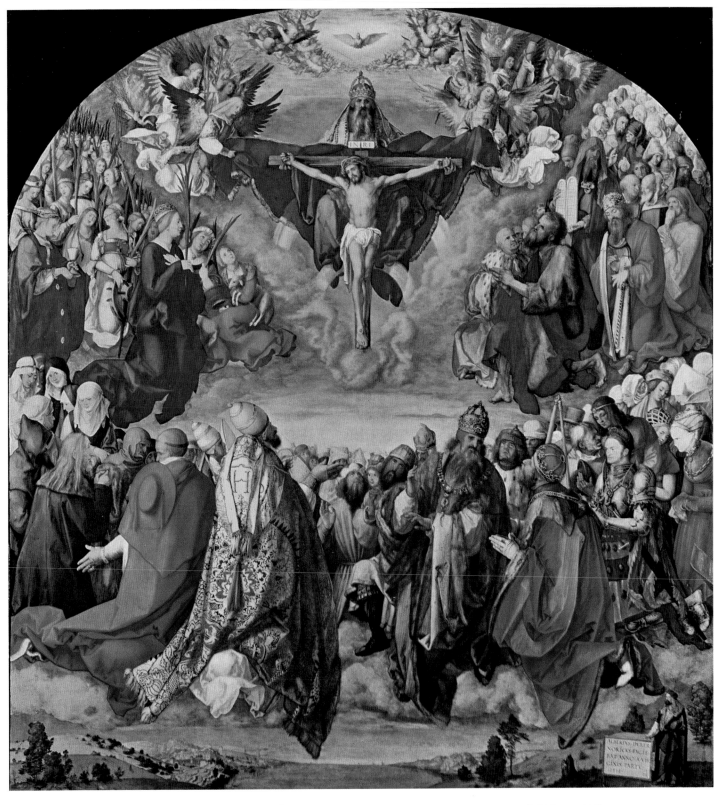

ALBRECHT DÜRER (1471-1528). THE ADORATION OF THE TRINITY, 1511. (56¾ × 51½″)
KUNSTHISTORISCHES MUSEUM, VIENNA.

Between 1502 and 1504 Dürer painted two of his finest pictures: the Munich *Nativity* and the *Adoration of the Magi* (Uffizi). In the former the scene is laid amid ruins set out in full perspective so that the spatial relations between the figures are clearly indicated, while thanks to a diagonal lay-out, they are integrated into the surrounding space. The ruined buildings of various shapes and sizes, the angels and the groups of people around the Holy Family make this picture seem frankly anecdotal, like an illustration, but this seemingly random assemblage of pictorial elements and their very quaintness endow the scene with a poetic, legendary glamour. Still more remarkable is the *Adoration of the Magi* which Dürer painted with especial care, for Frederick the Wise. Space is presented in depth and the eye is led to a faraway horizon by the positions of the figures, grouped in a roughly pyramidal schema. Spaced out both on the surface and in depth, these figures have a monumental quality, though still invested with that air of spontaneity and simplicity which is one of the charms of Dürer's art. Unlike the *Apocalypse* in which the emphasis on the horrific has something rather childish about it, this *Adoration* is human through and through, all grace and suavity. Though line is given the major role, the colors too play an important part—colors not only rich and brilliant, but exquisitely harmonizing with the over-all distribution of light and shade.

During his second visit to Venice, in 1505, Dürer, now one of the foremost artists of the day, was given a commission by the Fondaco de' Tedeschi (the local German colony) for a picture of the *Feast of the Rose Garlands* for the church of San Bartolomeo (now in Prague Museum). It shows, against a landscape background, the Confraternity of the Rosary, priests and laymen crowned with white roses (symbols of joy) and red roses (symbols of the Passion), gathered together to combat the heretics and do homage to the Virgin. In the foreground are Pope Julius II and the Emperor Maximilian I, and behind them an array of portrait figures reminiscent, like the composition, of Giovanni Bellini. But while keeping to the tradition and technique of the Venetians in a general way, Dürer has a vivacity of line distinctively his own.

Some of the portraits of his Venice period suggest that the painter had made a careful study of the art of Giovanni Bellini, who thirty years before had renounced the linear style and taken to representing form by arrangements of light and shade. Dürer, too, in his *Portrait of a Young Woman* (Berlin), dissolves line into form and, by the use of zones of light and shade, gives the image a plasticity more fully rendered than in his linear representations and reinforced by a dexterous handling of color. The *Portrait of a Young Man* (Hampton Court) also recalls Bellini (and Catena too), but with a more forcible directness in the style.

It was also in Venice that Dürer painted *Christ among the Doctors* (Thyssen Collection, Lugano). Some have thought to see in a portrait by Luini the Leonardesque prototype used by Dürer as his model. In any case the contrast struck here between beauty and ugliness is in keeping with a principle laid down by Leonardo, one of whose "caricatures" certainly suggested to our artist the figure of one of the Doctors. Indeed some have thought this to be a Gothic version of an original by Leonardo.

Two panels dated 1507 (both in the Prado), representing *Adam* and *Eve* respectively, were originally intended to illustrate the *Temptation*; actually they are, rather, two studies of the nude. Here the style is more Gothic than that of the *Temptation* engraved in 1504, where the artist was seeking to achieve classical form by means of relief, anatomical precision and an heroic-monumental treatment of the figures. But when in Venice, chiefly as a result of his contacts with Bellini, he realized that, when all was said and done, this sort of classicism did not come naturally to him—it was something imposed from without—and that he would do better to impart a hint of movement to his figures so as to make them less statuesque and more alive. In *Eve* the sinuous arabesque of the body, which seems to be faintly spinning on itself, is a distinctly Gothic touch, but modified by Italian influences and, like much post-Renaissance Gothic, tinged with Mannerism.

In 1511 Dürer completed the *Adoration of the Trinity* (Vienna), depicting the Trinity encircled by Saints and, below, the multitude of persons not admitted to God's presence. As the artist explains in an inscription on the decorated frame made by himself (Nuremberg Museum), this scene represents the aftermath of the Last Judgment. It is a vision of heaven with two distinct horizons: one extending behind the company of the Blessed and the other, lower down, on earth, stretching out into infinite distance. The visionary effect of this remarkable work, due to the "double horizon," is enhanced, paradoxically enough, by the realism of the perspective and the figures. For though the latter are portraits and space is normally presented, one has a feeling of being transported into a world far removed from earthly things. Hence, no doubt, the immediate success of this picture and its influence on later art. Moreover, its spirit was in keeping with certain aspects of the Counter-Reformation. Just as survivals from the Gothic had helped to modify the style of the Renaissance and point the way towards Mannerism and the Baroque, so medieval tradition, but for the obstacle of humanism, would certainly have been enlisted in the service of Counter-Reformation art.

Wholly taken up by this work, Dürer neglected color far more than he would have done in Venice. Indeed it seems that after painting it he temporarily abandoned painting in favor of engraving and his discoveries in the former art led him to make changes in his treatment of chiaroscuro with a view to securing more elaborate effects. Noteworthy among the engravings of this period is the *Trinity* (1511), a woodcut which by some optical illusion seems permeated with Titian's color-light. The same synthesis of light and shade is also realized with brilliant success in a dry-point engraving, *St Jerome by a Pollard Willow* (1512).

By dint of seeking to obtain more varied massings of light and shade in his engravings, Dürer came to appreciate better Grünewald's achievement and, like him, to stress emotive values, to tend towards mystical effusion and a more expressive luminism. But his fiery temperament led him towards a mysticism that was something other than religious ecstasy; rather, a Faustian vision of the world. It was perhaps this new insight into Grünewald's work that gave rise to his three most famous engravings: *Knight, Death and Devil* (1513), *St Jerome in his Study* (1514) and *Melencolia I* (1514).

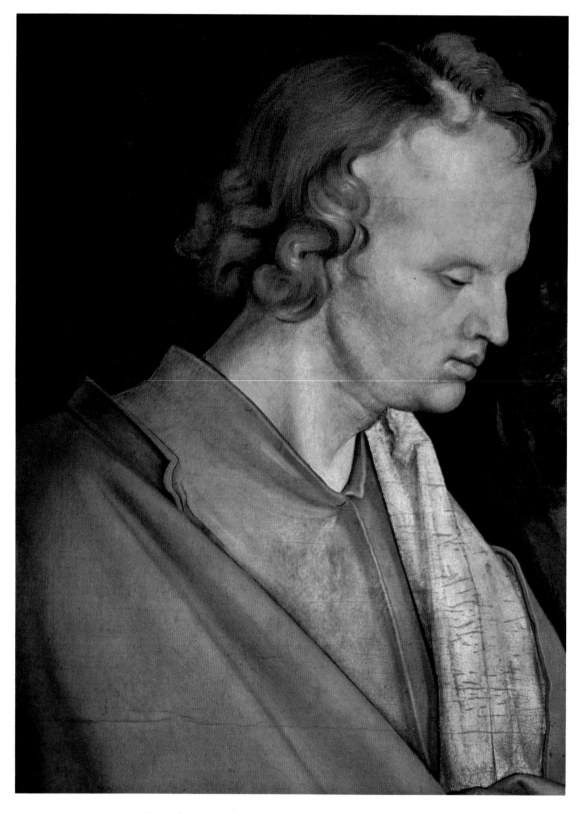

ALBRECHT DÜRER (1471-1528). THE FOUR APOSTLES, DETAIL: ST JOHN, 1526.
ALTE PINAKOTHEK, MUNICH.

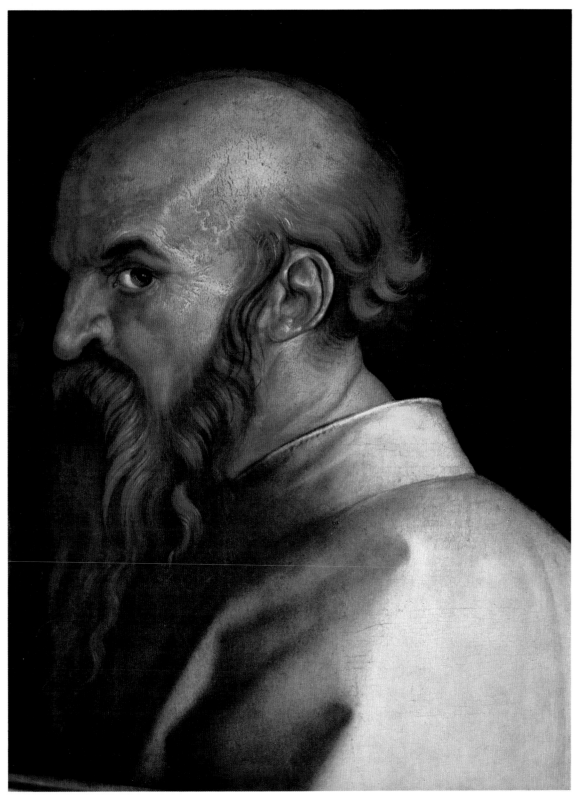

ALBRECHT DÜRER (1471-1528). THE FOUR APOSTLES, DETAIL: ST PAUL, 1526.
ALTE PINAKOTHEK, MUNICH.

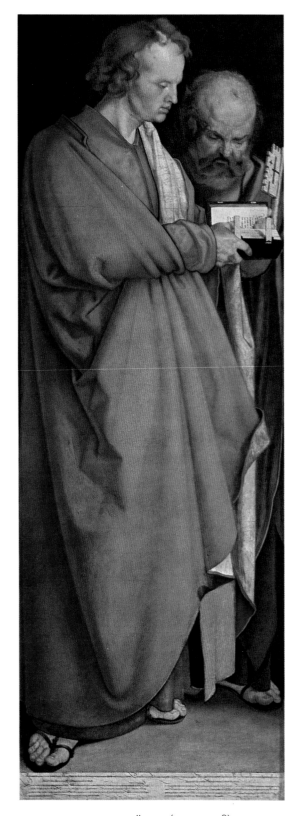

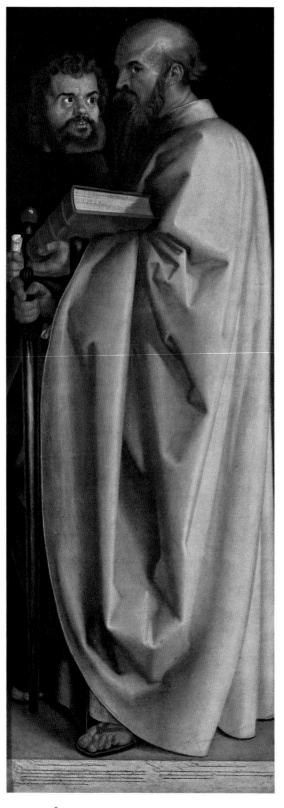

ALBRECHT DÜRER (1471-1528). THE FOUR APOSTLES, 1526. ALTE PINAKOTHEK, MUNICH.
ST JOHN AND ST PETER (84¾ × 29⅞″). ST MARK AND ST PAUL (84¼ × 29⅞″).

Dürer, it will be remembered, had been moved by a false report of Luther's murder to bid Erasmus (who in 1501 had written his *Handbook of the Christian Soldier*) to become "the Knight of Christ," to defend the Truth and win the martyr's crown. In the engraving he shows the "Christian Soldier" marching boldly forward, giving no heed to the devil who dogs his steps. While the armor, Death and the devil conform to the time-honored German tradition, the posture of the Knight reminds us of Donatello's monument at Padua, while the horse derives from a Leonardesque model. Though these anomalies weaken the unity of the composition, the contrast between medieval and Renaissance elements heightens its spiritual significance. Dürer has here personified so to speak the new religious aspirations of his epoch, and this work is far more than a picturesque illustration of a typically medieval theme.

St Jerome in his Study, on the other hand, is a masterpiece of scientific perspective and every object is assigned its geometrically correct place. Nevertheless the ebb and flow of light and shade playing across the neatly ordered, schematic lay-out brings the whole scene to vibrant life. When painted by an Italian artist—the picture in the National Gallery, London, probably by Antonello da Messina, is a case in point—the same subject had perhaps more spontaneity and certainly was less elaborately worked out. But this very elaboration led Dürer to give the well-worn theme an unconventional turn. Other artists had used it to celebrate the life of contemplation, whereas the scene that Dürer conjures up is pervaded with a rankling unrest that once again is Faustian in mood. So much so that we are reminded not of Antonello but, rather, of Rembrandt.

Nor is there any trace of contemplation, of spiritual self-communing or ordered thought in the *Melencolia I*, so much admired by Melanchthon. This woman is the effigy of despair, the compass she is holding rests inactive, everything around her is lying in disorder, the building behind her is unfinished, even the dog seems *in extremis*. As Panofsky has observed, this scene links up with the ancient idea of the four "humors" or "temperaments" of man, most unfortunate of which was melancholia since it came from Saturn. In Dürer's plate the melancholic humor is associated with a litter of scientific instruments as if to emphasize the plight of the artist or intellectual, a misfit in the social system. Since melancholy arises from the predominance of the imagination over the reasoning faculty, it ranks first in the scale of values—hence the number added to the inscription: *Melencolia I*. It expresses the artist's profound conviction of the futility of all human effort, the bankruptcy of "science."

From 1512 to 1519 he was in the employ of Maximilian I. For him he designed the large, composite woodcuts known as *Triumphal Arch* and *Triumphal Procession*. Besides a host of Gothic reminiscences, the patterning of the arch contains hermetic allusions in the form of emblems culled from the *Hieroglyphica*, a treatise on Egyptian hieroglyphs by Horus Apollo (2nd or 3rd century A.D.) which, when published in 1505, had a great vogue in humanist circles. Dürer's previous work had made it clear that decoration was not his forte and since his aim here was essentially decorative, these woodcuts must be written down as failures, while the plethora of details effectively prevents their being assimilated to Baroque.

According to some accounts, Dürer underwent a long period of depression towards the close of his life. This was due to the bitter religious conflict then raging in Germany and his uncertainties about the path to choose as a good Christian. In 1519, however, he definitely espoused the cause of Luther who, he said, "had delivered him from so great an anguish of mind." He now gave up painting non-religious subjects and sought to purge his mind of the humanism he had so laboriously imbibed.

In 1520 Dürer traveled to the Low Countries and made a stay at Antwerp. During this journey he painted several very fine portraits. *A Gentleman* (Prado) and *Bernhart von Resten* (Dresden) have quite exceptional vivacity and forcefulness, while certain characteristic accents—in the hair for example—show that he was moving away from the Venetians and towards the contemporary Flemish masters. From this trip Dürer returned a sick man (he never shook off the effects of a fever contracted in Holland), more and more distressed by the turn of events in the religious life of his country. This distress is reflected in a drawing of himself made at Basel in 1522, which shows him, in an *Ecce Homo*, as a desolate, defeated aging man with nothing left of the "Nazarene" of an earlier day, with flowing locks, rejoicing in his beauty.

He had intended to return to Antwerp to paint two altarpieces, a *Crucifixion* and a *Virgin with the Ancestors and Parents of Christ and Angel Musicians*, but though he spent infinite pains on the preparatory work, neither altarpiece ever saw the day. Only two panels of the second, depicting four saints intended to stand on either side of the Virgin, were completed. Wrongly named the *Four Apostles*, these four figures represent Sts John the Evangelist and Peter, Sts Paul and Mark. Dürer donated them to the City of Nuremberg, writing on the frame a warning against heresies and false prophets. For Nuremberg, now Lutheran, had to struggle against the fanatics and *illuminati* preaching a social as well as a religious revolution. Under the circumstances a "Virgin attended by Saints" would have seemed too Catholic in spirit, so he painted the saints only, giving prominence to Paul and John, saints particularly esteemed by Lutherans. In this, his last big work, we find Dürer's creative power and technical proficiency at their highest. Never before had he painted figures so grandly conceived, comparable with those of the greatest Renaissance artists. But there is nothing Italian in the expressions of the faces, which have a typically Germanic, Lutheran grimness. Here the divided purposes we sense in Dürer's personality from the very start commingle, but, far from being reconciled, make no secret of their antagonism. In these majestic figures we have both a final manifestation of Dürer's unquiet spirit and an epitome of his art.

HOLBEIN Hans Holbein the Younger is undoubtedly one of the most popular 16th-century German artists. Though Dürer is universally acclaimed as a great master, he is somewhat inaccessible, at times recondite, and while we cannot fail to recognize the power of his creations, they are apt to disconcert us. As for Grünewald, his art is profoundly disturbing, instinct with an exalted spirituality, yet it can hardly be said he is a popular artist in the general acceptation of the term. But everybody can enjoy a Holbein portrait, such is its union of fine craftsmanship and subtle characterization,

of elegance and dignity, and such its atmosphere of assured well-being, whether the sitter is the Burgomaster of Basel, Erasmus of Rotterdam, or Henry VIII and his ill-starred wives. But these portraits tell nothing or next to nothing about Holbein himself and his reactions to his models. Nor can we learn anything about the man he was from his religious scenes or from his many decorative works (only the preliminary drawings for which have survived), or from his innumerable woodcuts and copperplate engravings—all of them completely impersonal, non-committal. What they have in common is a technical perfection that the artist seems to have achieved quite effortlessly, almost without giving thought to it. Holbein, too, was schooled in the Gothic tradition (inculcated by his father), but he assimilated the lessons of Italian art far more readily and thoroughly than Dürer and had no trouble or qualms about solving a problem which presented itself to some of his contemporaries as a well-nigh insoluble dilemma. No other German painter had an apprehension so instinctive and complete of the Italian ideal of the beautiful. He possessed what Vasari, speaking of Raphael, called "an amazing natural facility," but while Raphael makes us feel the love he brought to the creation of a beauty all his own, Holbein shows no trace

HANS HOLBEIN (1497/98-1543). THE ARTIST'S FAMILY, 1528-1529. (30¼ × 25⅛")
KUNSTMUSEUM, BASEL.

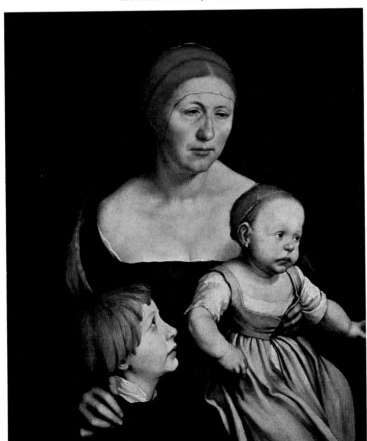

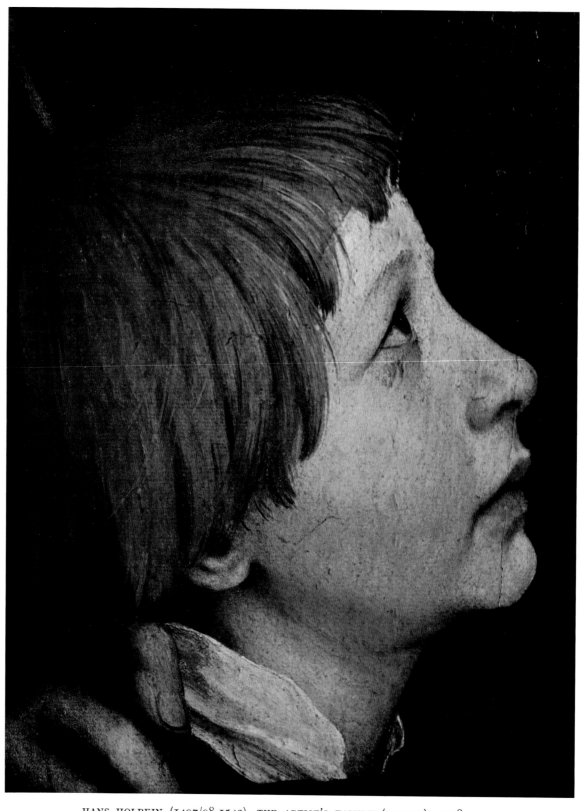

HANS HOLBEIN (1497/98-1543). THE ARTIST'S FAMILY (DETAIL), 1528-1529.
KUNSTMUSEUM, BASEL.

of any such emotion. That, in fact, is one of his limitations. Holbein was a superb technician and gifted with a natural taste superior to that of his contemporaries which enabled him, while bringing out the characters of his sitters with power and subtlety, to give them a distinctive elegance. But we can never tell how he felt towards them; whether he liked or disliked them; even if they interested him at all. Though perhaps one of the finest portrait painters of all time, he falls short of real greatness as an artist.

To this general rule there is one exception: the family portrait of his wife and his two children. When after a two years' stay in London he returned to Basel in 1528, he found his wife ill and depressed by his long absence. Departing for once from the objectivity of the professional portraitist, Holbein here reveals both his emotions as a father and husband and a sympathetic understanding of his models' inner life. Though the figures do not, perhaps, tell out so strongly as in his other portraits and lack their sumptuous embellishments, such is the spiritual insight here revealed that this picture takes a very high place in Holbein's œuvre.

Grünewald had fraternized with the revolutionary zealots; Dürer was an ardent partisan of Luther; Holbein, on the other hand, was a friend of Erasmus and Sir Thomas More, both of them advocates of an enlightened Catholicism. Familiar with Italian art theory and practice, he painted scenes of ancient history. His way of living, his choice of friends and his works prove him to have been a cultured man, and it was probably his humanistic outlook that prevented him from collaborating with the zealots when in 1529 they got the upper hand in Basel.

Born at Augsburg in 1497 or 1498, Holbein went to Basel in 1515 in the capacity of assistant to Hans Herbst. A year later, however, when he was only eighteen or nineteen, he painted the portrait of the Burgomaster and his wife—which shows that he had set up as an artist on his own account. Next year he traveled to Lucerne to make some decorations, then to Milan where, under the influence of Italian art, he modified his style. In 1519 he returned to Basel, where, having acquired the rights of citizenship in the following year, he built up an extensive practice, painting several portraits, religious pictures and decorations in the Town Hall. In 1524 he journeyed to France, and put in a stay at Lyons where he saw Clouet's work and was commissioned by local printing-houses to make two sequences of woodcuts, the *Dance of Death* and *Icones Veteris Testamenti*. But since as a result of the Reformation there now was less demand for works of art, Holbein decided to try his luck in London where, thanks to a letter of introduction from Erasmus, he secured the patronage of Sir Thomas More, who was loud in praises of his abilities. On his way to England he had stopped at Antwerp where he called on Quentin Massys. After making several portraits in London he returned to Basel in 1528. The Protestants were now in the saddle and busily engaged in "purifying" churches and palaces by the wholesale destruction of the works of art adorning them. Though Holbein did not ally himself with the Reformers, he was careful, when decorating the Town Hall, to illustrate biblical themes instead of the subjects from Roman history he had used in previous decorations. In 1532 he migrated for the second time to London, where there was a great demand for his portraits, and he

was now appointed Court Painter to Henry VIII. On several occasions he was sent to the Continent to make portraits of ladies whom the king proposed to marry. He remained in London until his death in 1543.

His first large portrait was that of Jacob Meyer, Burgomaster of Basel, and his wife. Although containing reminiscences of his father's style, the technique is crisper, more precise; in the background are two triumphal arches inspired by one of Hans Burgkmair's prints. The *Bonifacius Amerbach*, painted in 1519, has all the forceful realism we associate with Holbein's portraits, but he had not yet attained the objectivity and detachment distinctive of his later art. It is in the portraits of Erasmus made in 1523, when Holbein was only twenty-six, that these appear for the first time.

Under Grünewald's influence he painted the macabre *Dead Christ* in Basel Museum and drew a very striking *Ecce Homo* (Berlin). The *Lais Corinthiaca* of 1526 (Basel), an eye-pleasing portrait of a courtesan, shows the direct influence of Leonardo. Seemingly attaching little importance to the difference one would expect to find between a depiction of the Virgin and that of a young woman of easy virtue, he used the same type of figure in the painting of the Burgomaster's family in prayer before the Virgin, made for the palace of Prince William of Hesse at Darmstadt: a work effective in its way, if too blatantly materialistic. The eight scenes of the *Passion* (Basel) show that Holbein had fully mastered the perspective representation of space and Leonardesque *sfumato*. Still, this is not one of his best works; in it his employment of *sfumato*, a technique calling for extreme discretion and apt to decline to sentimental prettiness, led Holbein towards a sort of mannerist artificiality. More spontaneous and pictorially far more rewarding was his use of *sfumato* as a means of realizing effects of light and shade that linked up with Flemish tradition, as in the *Adoration of the Shepherds* (Freiburg-im-Breisgau). The shutters painted for the organ in Basel Cathedral, now in Basel Museum, are the sole surviving examples of Holbein's decorative ensembles (others being known only by drawings or copies). Despite the skill displayed, the figures are hardly a success and there is an even greater over-crowding of natural elements —trees and plants—than in similar Italian works. Holbein had not much imagination, as can be seen from his engravings, which are weak in the illustrative details. Even the fifty-eight woodcuts in the picture sequence of the *Dance of Death* and the ninety-one in *Icones Veteris Testamenti* (Old Testament scenes), world-famous though they are, have little real artistic value.

To see Holbein at his best we must turn to the portraits made in London. They are more broadly treated than his earlier portraits and show that he was breaking new ground. The figure, for example, is given an appropriate setting, with accessories of various kinds. Holbein, in fact, was seeking to transform the portrait pure and simple into a "picture"—one in which everything was calculated to bring out the wealth and elegance of the person or persons represented. This method, however, tended to enhance the sociological rather than the artistic significance of the paintings. In point of fact his most completely successful portraits, those which today we can admire without reserve, are the lightly tinted drawings most of which are now in Windsor Castle.

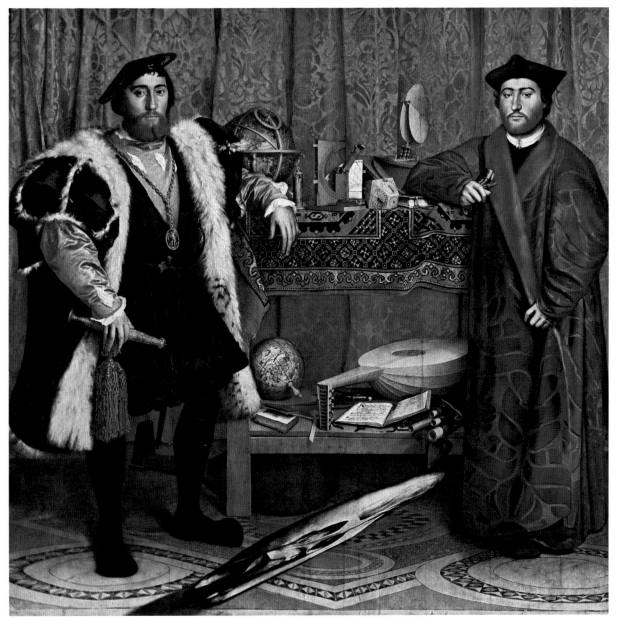

HANS HOLBEIN (1497/98-1543). THE AMBASSADORS, 1533. (82 × 82 ¼″)
REPRODUCED BY COURTESY OF THE TRUSTEES, NATIONAL GALLERY, LONDON.

In these the artist did not linger over rendering form in detail; on the contrary, he reduced linework to a minimum, merely hinting at the presence of the body—and thereby created drawings which, for purity of line, have never been excelled.

Some of Holbein's large-scale portraits are unique of their kind, nothing short of miracles of craftsmanship. Particularly noteworthy are the *Portrait of Georg Gisze* (Berlin)—Gisze was a wealthy German merchant settled in London—*Derich Born* (Windsor), *Robert Cheseman, the King's Falconer* (The Hague) and, last but not least, *The Ambassadors* (National Gallery, London). The two figures in the last-named picture

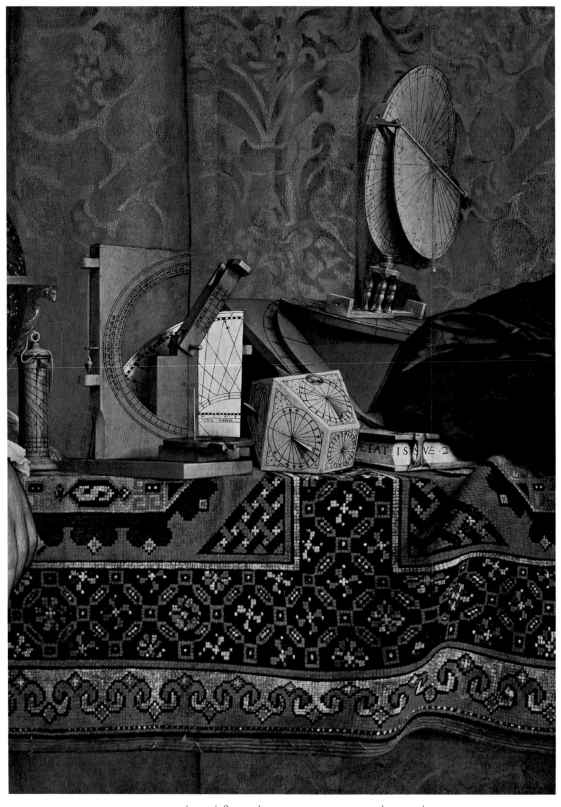

HANS HOLBEIN (1497/98-1543). THE AMBASSADORS (DETAIL), 1533.
REPRODUCED BY COURTESY OF THE TRUSTEES, NATIONAL GALLERY, LONDON.

are the ambassador Jean de Dinteville and Georges de Selve, Bishop of Lavaur. Both are shown almost full face and there is no visual link between the figures except the setting in which they are placed: a room full of books and precious objets. The musical, astronomical and mathematical instruments are rendered with illusionist realism; yet something in their disposition creates a vaguely "surrealist" atmosphere, intensified by the queerly elongated representation of a skull lying across the carpet. This effect is heightened by the trance-like rigidity of the figures and the preternaturally sharp definition given the various objects in the room.

On the other hand the portraits of *King Henry VIII* (Rome), *Edward, Prince of Wales* (Washington), *The Duke of Norfolk* (Windsor) and *Anne of Cleves* (Louvre) are typical show-pieces; sumptuous, lavishly ornate, self-consciously elegant—a far cry indeed from that happy ease which, according to Castiglione, should be the ideal of the perfect

HANS HOLBEIN (1497/98-1543). THE AMBASSADORS (DETAIL), 1533.
REPRODUCED BY COURTESY OF THE TRUSTEES, NATIONAL GALLERY, LONDON.

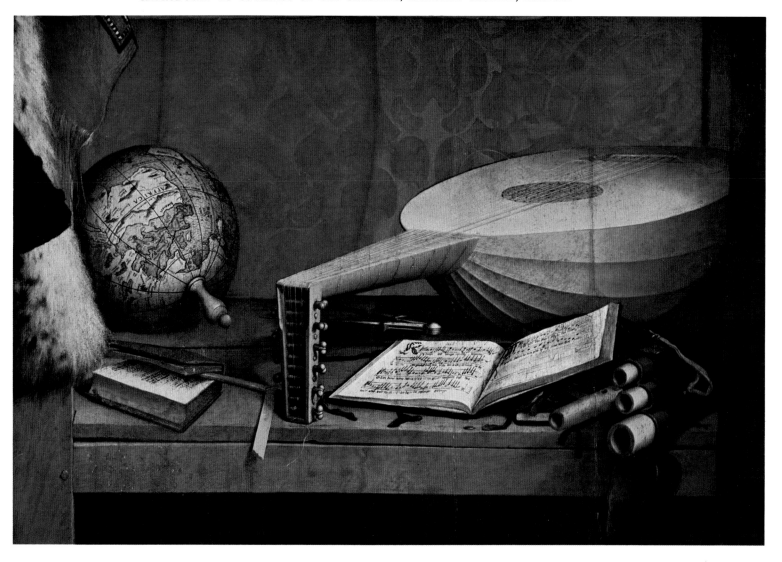

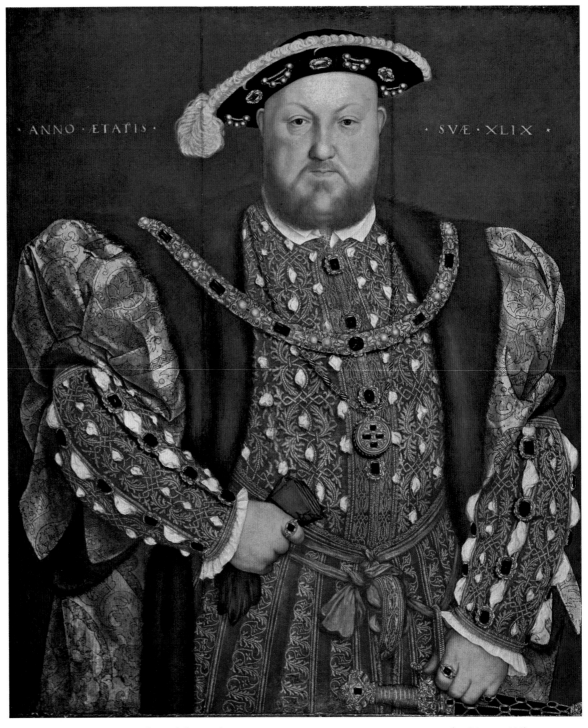

ANNO · ÆTATIS · · SVÆ · XLIX ·

HANS HOLBEIN (1497/98-1543). PORTRAIT OF KING HENRY VIII, 1540. (34¾ × 29½")
GALLERIA NAZIONALE, ROME.

courtier and the master artist. Nevertheless the *Portrait of a Young Man* (Vienna) and the *Self-Portrait* (Uffizi) reveal both a profound psychological insight and Holbein's amazing power of making a painted likeness seem a living presence.

Like Holbein, Lucas Cranach the Elder owes his fame chiefly to his portraits. Though these speak for an artistic personality remarkable in many ways, they lack the elegance and grace—typically Italian qualities—that we find in Holbein's work. For Cranach was out of sympathy with the spirit of the Renaissance, and devoted heart and soul to the Gothic art, realistic in trend, that was its avowed antagonist. For this reason his work was much to the taste of his fellow Germans.

Cranach was born in 1472 at Cronach (whence he derived his name) in Upper Franconia. After studying under his father he came under Dürer's influence. In 1502 he went to Vienna where there was then a vogue for landscape painting, a genre in which he was destined to excel. In 1505 he was appointed Court Painter to Frederick the Wise of Wittenberg, Prince Elector of Saxony. In 1508 he was sent to the Netherlands to paint the portrait of the boy who afterwards became the Emperor Charles V. Then, having struck up a friendship with Luther, he joined the Reformation movement and began to take part in the public life of Wittenberg, being elected a town councillor in 1519 and holding the office of Burgomaster twice (in 1537 and 1540). On his return from the Diet of Worms (1521), Luther wrote him an affectionate letter and Cranach made a portrait of his friend disguised as a friar in order to escape arrest on his way back from Worms. In 1526 he painted the wedding portrait of Luther and Catherine von Bora. At the age of eighty (in 1552) he moved to Weimar, where he died in 1553.

The portraits of his early years, notably that of Johannes Cuspinian and his wife (Winterthur), display remarkable energy and vivacity. Still quite a young man, Cuspinian held the post of Rector at Vienna University, was an accomplished humanist and a much esteemed poet. Cranach portrays him in rich attire against a landscape background that at once sets off and complements the figure. Several of his other Viennese portraits have no less dignity and expressive power, but one hesitates to describe them as truly human-istic in conception. For here and there we can discern glints of irony, much more in the spirit of Late Gothic than in that of the humanist artists whose work has, uni-formly, a stately, monumental quality.

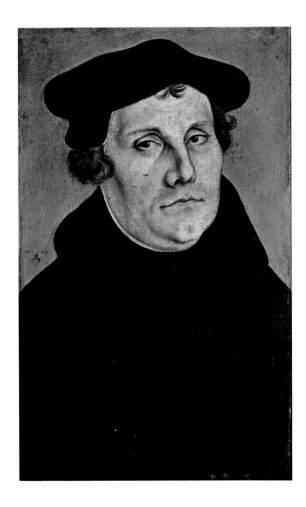

LUCAS CRANACH (1472-1553). PORTRAIT OF MARTIN LUTHER, 1529. (14⅜ ×9″) UFFIZI, FLORENCE.

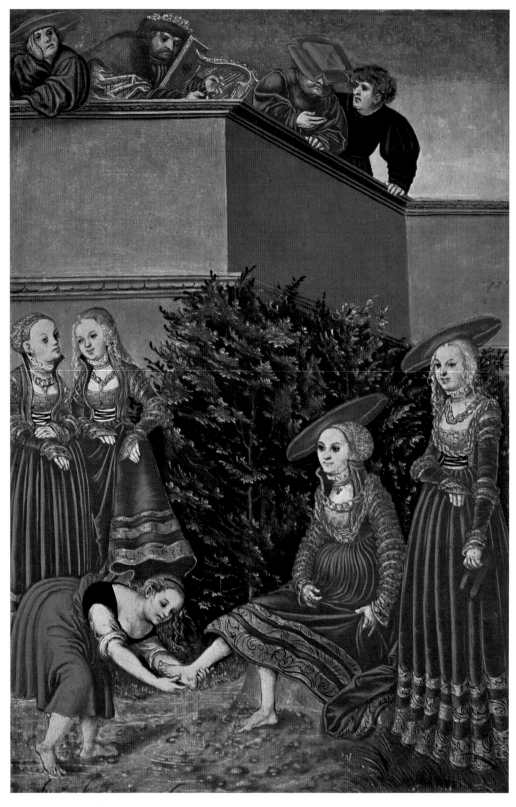

LUCAS CRANACH (1472-1553). DAVID AND BATHSHEBA, 1526. (14⅛ × 9⅜″)
NEUES MUSEUM, WIESBADEN (PROPERTY OF THE KAISER FRIEDRICH MUSEUM, BERLIN).

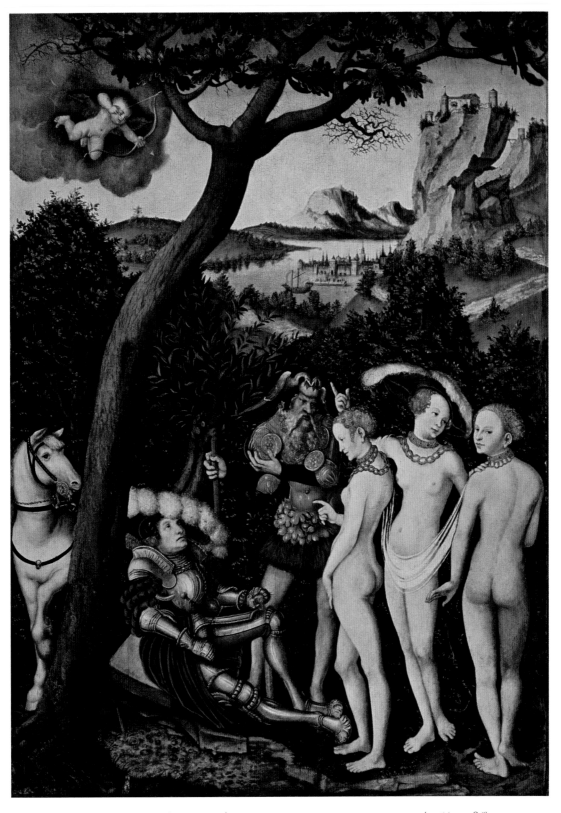

LUCAS CRANACH (1472-1553). THE JUDGMENT OF PARIS, 1529. (40⅛ × 28″)
BY COURTESY OF THE METROPOLITAN MUSEUM OF ART, NEW YORK.

The *Portrait of Martin Luther* (Uffizi), made in 1529, is at once a wonderfully expressive character study and a model of pictorial construction. Here, keeping to the traditional Gothic style, the artist has not overstressed realistic details, whereas in his portrait of Luther's parents he falls into this error, with the result that the spiritual significance of the work is blurred.

The distaste that Cranach felt for humanism and the art theories stemming from it is illustrated by the contrast between two pictures of the same model, Cardinal Albrecht of Brandenburg. The first (Darmstadt), painted in 1525, might almost have been titled "St Jerome in his Cell"; the second (Berlin), painted in 1527, "St Jerome in the Wilderness." In the Darmstadt picture the painter's inspiration seems to have failed him in his attempt to solve the problem of .representing the interior of a room in scientifically exact perspective by an interplay of zones of light and shade; in the Berlin picture, on the other hand, he has given free rein to his creative imagination, since, being less realistic, the subject permitted him to introduce an element of fantasy and charge the scene with magic overtones.

The *Portrait of Doctor Johannes Scheyring* (Brussels), painted in 1529, has intense vitality, though it must be admitted that Cranach has made his sitter look more like an ape than an esteemed physician. On the other hand his likenesses of children, such as the *Prince Moritz von Sachsen*, show him in a gentler mood and the figures have all the fragile charm of early youth. In his *Ideal Portrait* (1526) of Sibyl of Cleves, it seems that what he aimed at was to sublimate the model into a vision of more than human splendor by clothing her in fantastically rich apparel. This portrait illustrates one of Cranach's outstanding qualities, which, however, is seen to best advantage in his nudes: his flair for decorative effects. He clearly took a particular delight in painting the nude figure, as we can see in his *Adam and Eve* and his mythological scenes such as the *Judgment of Paris, Venus and Cupid, Diana and Apollo*. But what gives these figures their singular appeal is not their plastic values or their harmonious proportions; still less the painter's knowledge of anatomy. Cranach uses them as pretexts for flowing surface decoration in which Gothic line is given an ingenious twist to stress the presence of some unlooked-for detail or unwonted object, as when some of the nudes are shown wearing enormous hats. We find touches of erotic suggestiveness which seem hardly in keeping with Lutheran austerity or what was to be expected of a worthy Burgomaster of Wittenberg; they probably derive from the "courtly" style of Late Gothic, and also from a feeling of the need for an occasional respite from puritanism.

Cranach's landscapes are particularly attractive; a good example is the *Stag Hunt* (ca. 1529) in Vienna. Here the composition is spangled with a host of tiny specks of light, bringing the entire scene forward on to the picture surface, and the perspective projection is of a purely fantastic order. Spatial arrangement is governed by the Gothic arabesque, reinforced by a color-scheme in which green predominates. Color plays an important part in Cranach's art; it is wedded to form with the happiest results in *Judith and Holofernes* (Vienna), whose reds and yellows sing out on a dark ground, each zone of color containing tracts of chiaroscuro that take the place of light.

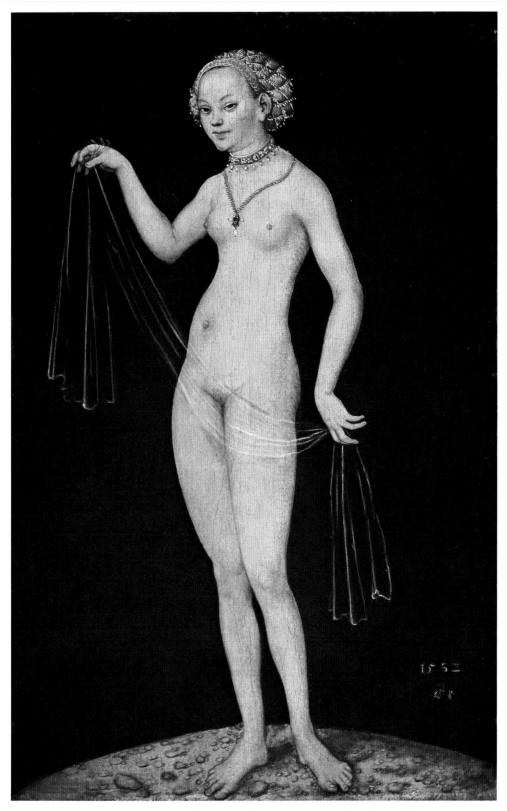

LUCAS CRANACH (1472-1553). VENUS, 1532. (14½×9¾″)
STÄDELSCHES KUNSTINSTITUT, FRANKFORT.

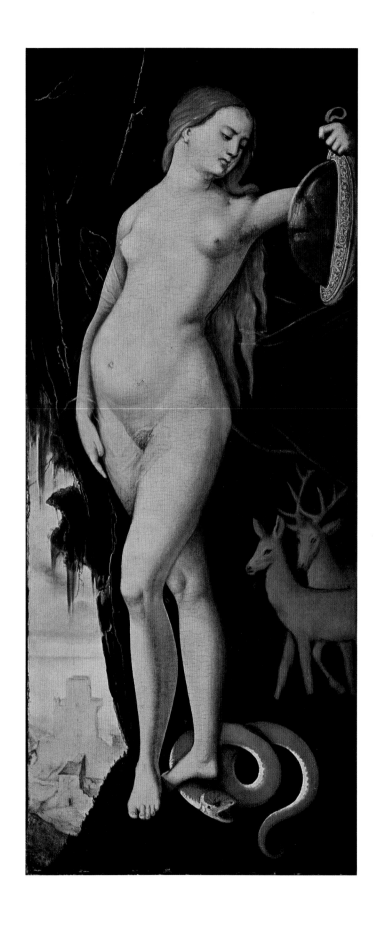

The *Earthly Paradise* (1530, Vienna) is a green landscape sprinkled with minute touches of light, against which the figures stand out, clearly defined by bold, emphatic coloring. In sum, Cranach's color orchestration might be described as a luminist interpretation, on the boldest, most fanciful lines, of the Gothic miniature.

There is nothing of Dürer's or Grünewald's high morality, and equally nothing of Holbein's elegant humanism and smooth technical perfection in Cranach's work. Indeed he seems to take neither life nor art quite seriously. But he had an original personality and employed Gothic line and the colors of the illuminators to fine effect in those delightful pictures, whimsical, with a discreetly sensual appeal, which in his day were so greatly to the liking of the German princes and still mean much to all who can enjoy the divagations of an artist's fancy at its freest.

Hans Baldung Grien (or Grün) was born at Gmünd (Swabia) in 1484 or 1485. Nothing is known about his early training but traces of the art forms of Alsace, where the school of Schongauer was flourishing at the time, can be detected in the drawings and engravings of his youth. At Nuremberg he worked as Dürer's assistant and the affectionate relations between the two men persisted after Baldung left that town in 1505. He stayed four years (1512-1516) at Freiburg-im-Breisgau, but most of his life was spent in Strasbourg, where he held the post of Town Councillor and official painter to the Bishop's Court. He died in 1545.

<div style="float:right">HANS BALDUNG GRIEN</div>

His paintings prior to 1520 show a sense of plastic values not found in any other German artist of the time, while his delicate, jewel-like colors are reminiscent of 15th-century art. After 1520 he took to what might be described as plastic mannerism, making lavish use of lights and vivid colors; next, some five years later, in 1525, he adopted Cranach's Gothic line, while also showing signs of Italian influences, amongst others Marcantonio's. His major work is the altarpiece of Freiburg-im-Breisgau, in which his considerable gifts are seen at their best. The scene of the *Flight into Egypt* has the charm of an old-world folktale, while the *Nativity*, with its subtle effects of nocturnal light, is equally delightful in a different way. But of mystical emotion he had none, his feet were solidly planted on the earth and his *Crucifixion* fails to move us—evidently he knew nothing of Grünewald's art. He was, however, a very adroit draftsman, with a fine feeling for elegance of line; his drawings in white touches on dark paper are not only delicately perceptive but also reveal a familiarity with Renaissance techniques —foreshortening, for example—though without detriment to his highly personal style. He has a predilection for such subjects as Witches' Sabbaths and death under its grim or grotesque aspects, and strikes a note of healthy, robust sensuality even in works of a would-be edifying order. His skill in rendering volumes and his feeling for graceful form can be seen in *Venus* (1525, The Hague) and *Vanitas* (1529, Munich). Of all the German painters of the early 16th century none had a surer sense of style and by the same token none was nearer in spirit to the Renaissance.

◄ HANS BALDUNG GRIEN (1484/85-1545). VANITAS, 1529. (32⅝ × 14⅛″) ALTE PINAKOTHEK, MUNICH.

Linking up with the German tradition was a whole group of Swiss painters, one of them being Nicolas Manuel Deutsch. "Deutsch" was a translation of "De Alemanis," the Italianate name assumed by his family when they settled at Chieri, a small town near Turin. His grandfather returned to Bern where, about 1484, Nicolas was born.

NICOLAS MANUEL DEUTSCH (CA. 1484-1530). PYRAMUS AND THISBE. (59½ × 63¼″) KUNSTMUSEUM, BASEL.

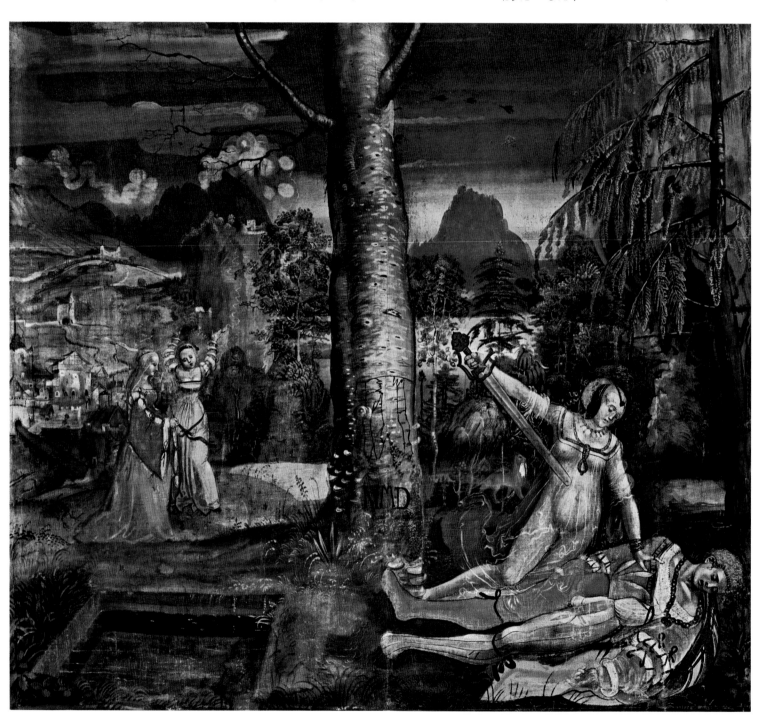

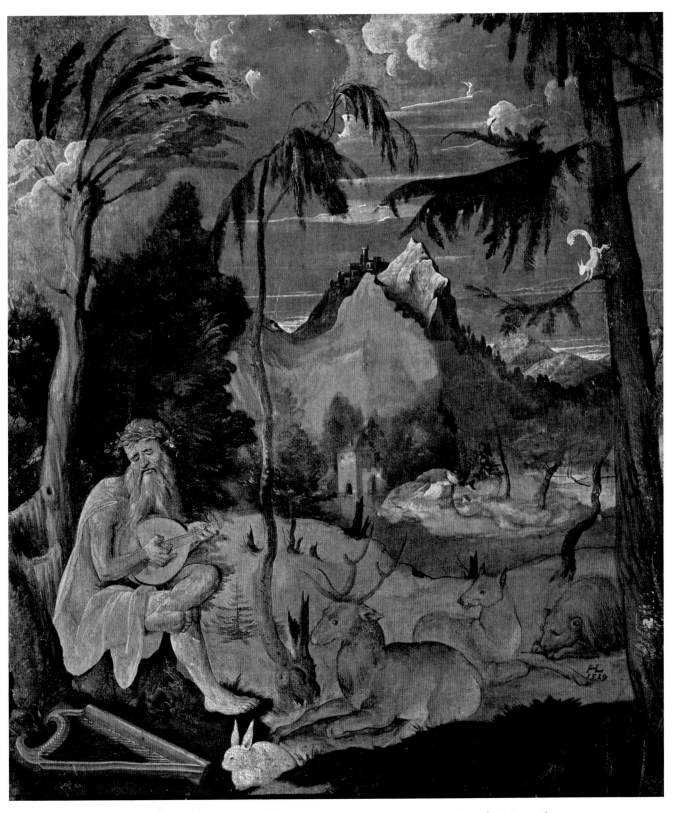

HANS LEU (CA. 1490-1531). ORPHEUS AND THE ANIMALS, 1519. (22¾ × 20″)
KUNSTMUSEUM, BASEL.

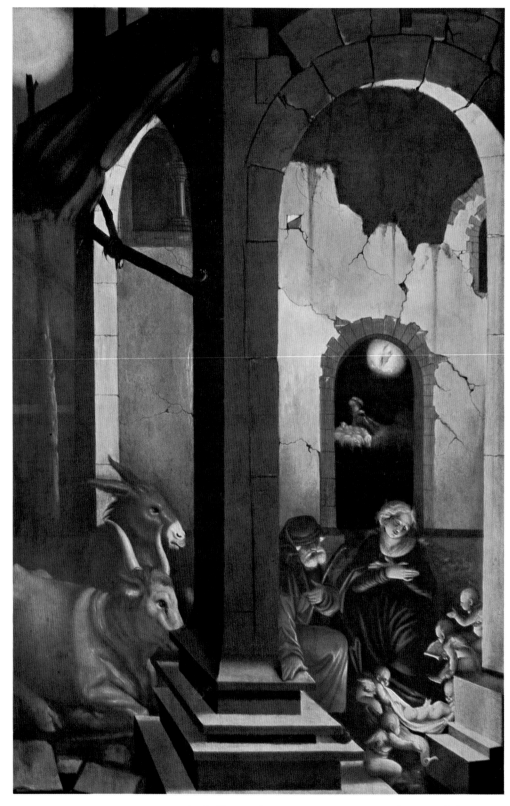

HANS BALDUNG GRIEN (1484/85-1545). THE NATIVITY, 1520. (41¾ × 28″)
ALTE PINAKOTHEK, MUNICH.

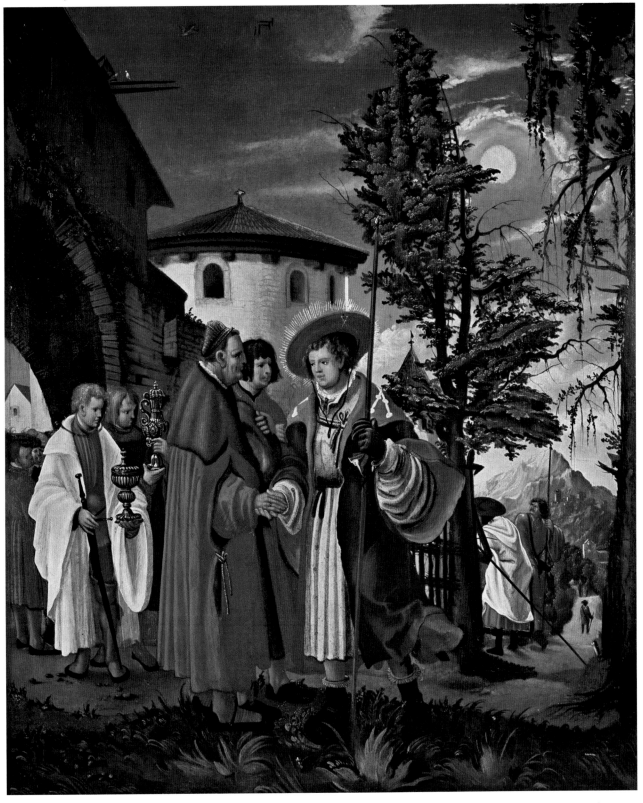

ALBRECHT ALTDORFER (BEFORE 1480-1538). ST FLORIAN TAKING LEAVE OF HIS COMPANIONS, CA. 1518.
(31⅞×26⅜″) THE ST FLORIAN ALTARPIECE. UFFIZI, FLORENCE.

After studying under Hans Fries, he traveled to Basel and South Germany, where he came under the influence of Dürer, Baldung Grien and the Italian engravers, though without breaking with Gothic tradition. Besides being a painter, he was a writer, a poet and, above all, a man of action. He fought in the Italian campaign in 1516 under Von Stein, and took an active part in the struggle with the Papacy. The work by which he made his name as an artist, his *Dance of Death* (1517-1520), has disappeared and is known only by a copy. He wrote two farces satirizing the Pope and clergy, which were performed during the 1522 carnival while he was at the wars in Italy. His political activities procured him a seat in the Council of Bern and in 1528-1529 he was sent on diplomatic missions to Zurich, St Gall and Baden. He died in 1530.

Deutsch was less a painter than a draftsman with a very lively imagination who put an immense vitality into his line. True, there were lapses in his taste; in the *Ten Thousand Martyrs*, for example, one of the panels of the Grandson altarpiece, he overdoes the hideousness of the wounds, while in his *St Anthony* he fails to make the monsters really terrifying. Nevertheless in some non-religious works, such as *Pyramus and Thisbe* and the *Judgment of Paris* (both in Basel) we cannot but admire the wit and fantasy with which he interprets the ancient myths, whose *dramatis personae* he boldly clothes in 16th-century costumes. No less attractive is the booklet dated 1520, now in Basel Museum, containing a series of vignettes of women and German foot-soldiers, in which an amazing delicacy and elegance of line is allied with fanciful decorative motifs; these little scenes might be described as guide-posts along the path of Gothic style towards an exuberant mannerism.

Another interesting Swiss painter was Hans Leu the Younger, born at Zurich about 1490 and trained by his painter father in the Late Gothic tradition. Between 1507 and 1513 he traveled in Germany, where he came in contact with Baldung Grien, Deutsch and also Dürer, with whom he started up a lifelong friendship. His most successful works are landscapes in which the Swiss Alps make what is perhaps their first appearance in painting. Hans Leu died in 1531.

ALBRECHT ALTDORFER

One of the things that strikes us most in the German painting of the first half of the 16th century is the new prominence given to scenes of nature. Grünewald's landscapes bear the imprint of his unquiet spirit; Dürer, in his watercolors, was the first to treat landscape as an end in itself. But it was left to Altdorfer to exploit the utmost possibilities of the landscape of fantasy.

Altdorfer was born at Amberg (Bavaria) a little before 1480; his father, Ulrich, was a painter, as was his brother Erhard Altdorfer. He was enrolled a citizen of Regensburg (Ratisbon) in 1505 and in 1509 the City Council paid him a large fee for a picture, thus testifying to their high opinion of his work. In 1513 he bought a house and in 1519, in his capacity as a member of the City Council, published the edict expelling the Jews from Regensburg; then he took part in building the Schöne Maria church on the site of the former synagogue. From 1526 until his death in 1538 he was City Architect and a member of the Council.

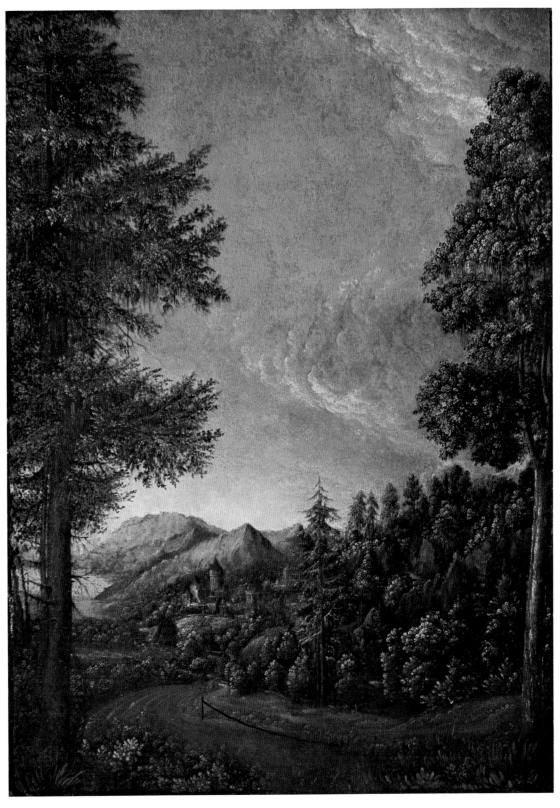

ALBRECHT ALTDORFER (BEFORE 1480-1538). DANUBE LANDSCAPE NEAR REGENSBURG, 1520-1525.
(11¾ × 8⅝″) ALTE PINAKOTHEK, MUNICH.

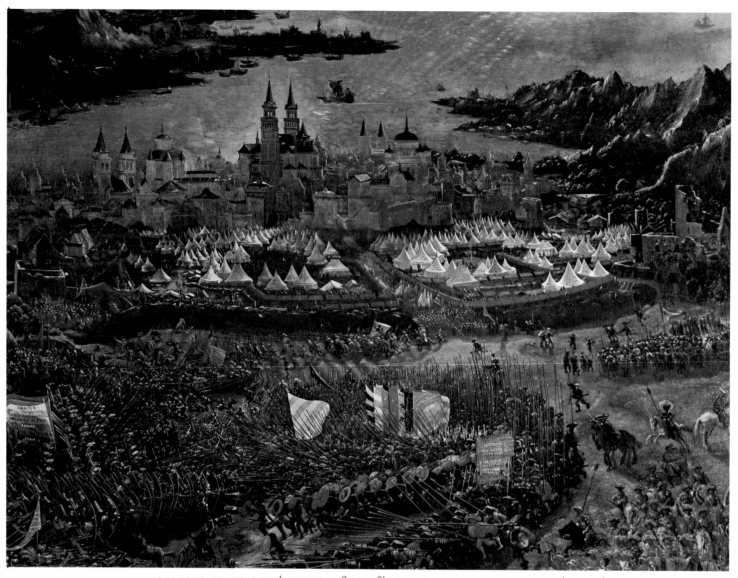

ALBRECHT ALTDORFER (BEFORE 1480-1538). THE BATTLE OF ALEXANDER (DETAIL), 1529.
ALTE PINAKOTHEK, MUNICH.

By general consent Altdorfer is one of the most typical artists of the Danubian
School which, amongst other painters, included Wolf Huber. He was influenced by
Dürer and Cranach and, at one stage of his career, by Grünewald. Also he profited
by the lessons of Italian art. But so strong was his personality that he not merely
assimilated but transformed all he took from others.

Friedländer distinguishes three phases in his artistic evolution. First, from 1507
to around 1520, when he painted small light-keyed pictures in which there is still some
indecision in the drawing, though the colors are altogether delightful. Next, towards
1520, he took to stronger colors and sensational effects, as in the St Florian altarpiece
(1518). Finally, in his last period, he calmed down, giving forms normal proportions
and dappling the picture surface with sudden gleams of light. It was in rendering the

ALBRECHT ALTDORFER (BEFORE 1480-1538). THE BATTLE OF ALEXANDER (DETAIL), 1529.
ALTE PINAKOTHEK, MUNICH.

ALBRECHT ALTDORFER (BEFORE 1480-1538). THE BATTLE OF ALEXANDER, 1529. (62 × 47 ¼″)
ALTE PINAKOTHEK, MUNICH.

mystic life of the forest that he excelled and there are reasons for believing him the first artist to make landscape the sole theme of a picture (Munich), to the exclusion of figures, and he thus may be regarded as a pioneer in this genre.

In an interesting article in the *Gazette des Beaux-Arts* (May-June 1953) Georg Gombrich points out that Leonardo and the Venetians were the first to recognize the intrinsic value of landscape, brought it into fashion and created a public for it. From humanism they had learnt that what counted most of all in a work of art was its aesthetic quality, not its "message," moral or anecdotal. Thus the landscape painters of the North found in Italy a ready market for their productions; Federigo Gonzaga, for example, bought (in 1535) no less than a hundred and twenty Flemish paintings, twenty of which were "fire pictures." In 1548 Vasari, writing to Benedetto Varchi, observed that "every cobbler had a German landscape in his home." In 1548, too, Paolo Pino explained why the Germans excelled in the art of landscape painting. Italy, he pointed out, being "the garden of the world," was more pleasing to the eye than any painting could possibly be. On the other hand, the artists of the North lived amid untamed forests which supplied them with excellent and exciting motifs. Pino was, in fact, describing what came to be known in the 18th century as the picturesque, and had in mind the peculiar appeal of "wild nature" to certain temperaments.

It was Altdorfer who made the happiest use of this new freedom, in those (to use André Gide's epithet) "gratuitous" landscapes, whose sole but signal merit consists in the prodigious scope he gave to his creative fancy. In his famous *St George and the Dragon* (Munich), the actors in the drama are hardly visible, what holds our gaze is the densely surging mass of the forest, with a narrow vista opening on a dim horizon. Painted on the surface, the tangled leafage is interspersed with flakes and shimmering lines of light; light, indeed, is the animating principle, seeping into the green luxuriance of the foliage or flashing forth from it in a haze of broken gleams. The raw material is real enough, the German *Urwald*, but by the magic of these light-rhythms the painter has imbued it with the glamour of an enchanted forest in some ancient legend. In the *Satyr Family* (1507) in Berlin the painter has thought up a weirdly primitive setting in keeping with the theme, and given free play to his imagination, the result being a landscape almost unique of its kind—Pino's "wild nature" transposed into the prehistoric age.

In the third book of his *Chirurgia* Paracelsus traced a resemblance between vegetable life and the human organism. "Plants grow in the same way as men, they have their skins and limbs, heads and hair. They have bodies and a nervous system; so sensitive is the stem that if you strike it the plant dies. They are bedecked with flowers and fruit, as man is gifted with the faculties of hearing, seeing and speaking." Elsewhere he says: "The body is a tree and life a flame consuming it." And it is in this spirit that Altdorfer tells us, so to speak, the life story of a landscape, in one of the pictures now in Munich. Man's presence is needless since, as he pictures it, the landscape itself is human. Framed between two great trees, peopled with wisps of dancing light streaming in glittering recession up the mountains, cliffs and clouds, the whole scene comes to life because it is a vivid reflection of the artist's inmost being.

In the *Battle of Alexander* (Munich) the landscape is charged with awe-inspiring, tragic grandeur. The commission for this picture was given by William IV of Bavaria, who presumably wished it to be an historical battlepiece of the normal kind. But the forms of the soldiers are so completely swallowed up by the landscape that they dwindle into leaflike streaks of living light. What gives the scene its compelling power is not the battle itself but its aspect of some cosmic cataclysm, in which everything is in commotion and the sky mottled with an unearthly, lurid glow. Leonardo endowed a scene of battle with a like cosmic significance; but Altdorfer gets his effect by the use of thrilling color. He is not out to enlarge our knowledge of the world, nor does he, like Leonardo, aim at any scientific validity; with an amazing sense of purely pictorial values, he builds up a world of sheer imagination.

INDEX OF NAMES

LIST OF ILLUSTRATIONS

INDEX OF NAMES

LIST OF ILLUSTRATIONS

PRINTED BY

IMPRIMERIES RÉUNIES SA

LAUSANNE

BINDING BY

GROSSBUCHBINDEREI H.+J. SCHUMACHER AG

SCHMITTEN (FRIBOURG)

Photographs by Louis Laniepce, Paris (pages 15, 24, 25, 34, 35, 40, 41, 75, 94, 95, 111, 112, 113), Claudio Emmer, Venice (pages 13, 14, 18, 19, 20, 23, 30, 31, 36, 37, 47, 48, 49, 52-53, 56, 65, 74, 76, 77, 97, 114, 115, 125), Hans Hinz, Basel (pages 5, 10, 44, 63, 80, 85, 86, 87, 91, 102, 103, 104, 107, 108, 116, 119, 120, 122, 123, 124, 127, 128, 129, 130), Henry B. Beville, Alexandria, Va. (pages 33, 117), Karl Meyer, Vienna (page 99), Bibliothèque Nationale, Paris (page 79), Life Magazine, New York (page 64), and Anderson, Rome (pages 60-61, 69).

PRINTED IN SWITZERLAND